PHOTOGRAPHY
FROM THEORY TO PRACTICE

PHOTOGRAPHY
FROM THEORY TO PRACTICE

MICHAEL E. LEARY

PUBLISHING COMPANY

Star

PUBLISHING COMPANY
P.O. BOX 68
BELMONT, CALIFORNIA 94002
(415) 591-3505

Cover photograph courtesy of Canon U.S.A., Inc.

Printed in the United States of America

ISBN: 0-89863-124-6

Table of Contents

Preface

Photography: From Theory to Practice, although a technical book, is meant for the beginner; no previous experience is necessary to understand and utilize the material this book presents.

Photography has become more and more popular as a hobby in recent years and has progressed to serious study not only in the United States but throughout the world.

Automatic equipment has widened the potential for creative photography by eliminating much of the worry about the technical side. Such equipment has also spawned a new interest in how photographic systems work and how to achieve the best results from this hobby. It is for these technically interested photographers that this book was written.

Photography: From Theory to Practice first discusses the interaction of light and other forms of radiant energy with photosensitive materials and utilizes this theoretical background to present the technical and practical applications of optics to photography. Numerous illustrations help explain lenses of different focal lengths and their relation to a lens of normal focal length. Novice and accomplished photographers alike will benefit from the discussion of the camera's basic features and of contemporary photographic equipment. The chapters on exposure and artificial light present practical examples that help the photographer put the technical information to immediate use. A new approach is used to simplify the subject of filters. Three chapters discuss the field of photochemistry and its practical application in the darkroom, including step-by-step illustrations on darkroom technique. The book concludes with a history of photography.

No single volume could possibly cover all the information now available on so vast a subject as photography, but *Photography: From Theory to Practice* does provide a broad introduction to photography's theoretical concepts and technical requirements. Whether the reader is a hobbyist or a budding professional, *Photography: From Theory to Practice* will provide the foundation necessary for lifelong enjoyment of photography.

Preface to the Second Edition

The Second Edition of *Photography: From Theory to Practice* retains the concise layout of the first edition, enhanced by new material and many new illustrations. The line drawings in chapters 1-3 have been clarified. Chapters 4-6 have new sections that display and explain the changes in equipment since the first edition. Additionally, the chapters on photographic processing have been expanded, including new sections on print errors and corrections.

While there are many changes in this second edition, I believe you'll find that this book fulfills its purpose: To help the beginning photographer put theory into practice.

Photography: From Theory to Practice, although a technical book, is meant for the beginner; no previous experience is necessary to understand and utilize the material this book presents.

Michael E. Leary

Acknowledgments

I would like to thank my wife, Terry, and my children, Michelle, Jason, and Kirstie, for putting up with all the time required for me to complete this book. I would also like to thank all my friends at Agfa-Gevaert, Eastman Kodak Co., and The Society of Photographic Scientists and Engineers for their vast help in securing some of the technical illustrations used in *Photography: From Theory to Practice*. A special thanks to Jon Schulenberger for his valuable critical reading and Patrick Dullanty for his help with the pin hole camera photographs section. I also thank all my former teachers and all my students, from whom I learn new concepts everyday.

Chapter 1
Radiant Energy

Vision is one of the most important human senses. It gives us information about light that is unobtainable from the senses of touch, smell, or hearing. Light itself, however, is only a very small portion of the total radiant energy in the electromagnetic spectrum. As we shall see, photography allows us to expand our senses into areas previously invisible.

Light

Light is defined as that part of radiant energy of which a human observer becomes aware through the visual sensations associated with stimulation of the retina of the eye. The measurement of light, its presence or absence and its quality, must be based on the human eye as the receptor.

The issue of individual differences in vision was clarified when research showed that most humans see that portion of radiant energy bordered by the sensations of blue light and red light. As shown in Figure 1-1, humans see green light best, and vision gradually falls off toward the blue and red ends of the visible spectrum. Under high levels of illumination, the human eye perceives most colors equally well. Under low levels of light, however, green is the color easiest to perceive.

Theories of Light

During the seventeenth century, Sir Isaac Newton theorized that light was made up of a stream of tiny particles, or corpuscles, emitted at high speed from a source. The impact of these corpuscles

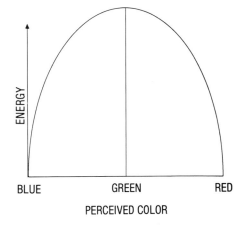

Figure 1-1 Human vision is confined to that portion of radiant energy from blue light to red light. Although the human eye can perceive information throughout this entire range, more information can be gathered from the center of the range of vision—green light.

on the eye produced the sensation of vision. Because the **corpuscular theory** did not adequately explain all aspects of light, further study followed.

During the eighteenth century, Christian Huygens postulated the **wave theory**. This theory stated that light is a form of wave motion in ether, a hypothetical medium that pervades all space, whether empty or full. The wave theory more easily explained the fact that transparent materials such as glass can transmit light.

Research continued, and in the late nineteenth century, James Clerk Maxwell suggested that light did indeed travel in waves, but as a continuous stream of energy rather than corpuscles. This theory was called the **electromagnetic wave theory** of radiation.

It wasn't until the turn of the twentieth century that some of the problems associated with the electromagnetic wave theory were explained by Max Planck, professor of physics at Berlin University. Planck's **quantum theory** of radiation proposed that radiation travels in waves, but as tiny packets of energy called **quanta**. Four years after Planck's announcement of the quantum theory, Albert Einstein extended it to light and called light's energy packets photons. Einstein theorized that light has a dual nature—packets of energy traveling in waves.

The proposed dual nature of light explains certain of its properties. Packets of light best explain the fact that gravitational fields affect the path of light and that light itself can exert pressure. During a lunar eclipse, for instance, the path of light from a distant star can be bent by the gravitational pull of the moon, leading the earthbound observer to the mistaken conclusion that the star had actually moved from its known position in space. The orbits of communication satellites also can be altered by the pressure of light, for when a satellite is on the sunny side of earth, its orbit is forced closer to the earth than when it is on the night side of our planet. However, other characteristics of light, such as the phenomenon of diffraction, can be explained only by the wave motion proposed by the quantum theory.

Diffraction. When light passes through an extremely small aperture—one too narrow for the height (amplitude) of the light wave—it does not produce an image of a small spot; rather, it spreads out over an area much larger than the aperture and produces an image that is unsharp, especially at the edges (Fig. 1-2). The smaller the aperture, the wider the spread of illumination. This phenomenon of **diffraction** acts to limit the minimum useful aperture of a photographic lens.

LIGHT WAVES

Figure 1-2 Diffraction occurs when light passes through an aperture that is too narrow for the height (amplitude) of the light wave, yielding an image that is larger than the aperture and unsharp, especially at the edges.

The Electromagnetic Spectrum

Wavelength. According to the quantum theory, all radiant energy travels in waveform. The distance from wave crest to wave crest or from trough to trough, called a **wavelength** (Fig. 1-3), is measured in nanometers (Nm). (One nanometer equals one billionth of a meter.) The entire electromagnetic spectrum consists of wavelengths from 10^{-6} Nm to 10^{14} Nm, or from less than one billionth of an inch to over six miles (Fig. 1-4).

The Visible Spectrum

As can be seen in Figure 1-4, visible light is an extremely small portion of the entire electromagnetic spectrum and ranges in wavelength from 400 Nm to 700 Nm. Within the visible spectrum, wavelengths from 400 Nm to 500 Nm are perceived as blue; from 500 Nm to 600 Nm, as green; and from 600 Nm to 700 Nm, as red.

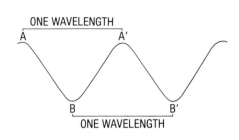

Figure 1-3 A single wavelengths defined as the distance from crest to crest (A-A') or trough to trough (B-B') and is measured in nanometers (Nm).

Figure 1-4 The electromagnetic spectrum.

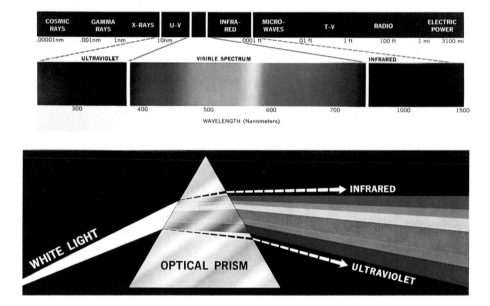

Photosensitive Materials. Photographic materials can be made sensitive to all visible light and can also be used to obtain information from outside the visible portion of the spectrum.

All photographic materials are naturally sensitive to blue light and all radiation of shorter wavelength. These materials are called **monochromatic** (Fig. 1-5a). Wavelengths longer than blue have less energy, so photographic materials must be chemically sensitized with carbocyanine dyes in order to record them. Photographic materials with their sensitivities extended to include the green area

Figure 1-4a Dispersion. White light breaks up into its spectral components, with the shorter wavelengths being bent the most. (See text, p. 10)

of the spectrum are called **orthochromatic** (Fig. 1-5b). Further treatment with carbocyanine dyes will produce a material that is photosensitive through the red region of the spectrum. This type of material is called **panchromatic**; all modern amateur camera films are of the panchromatic type (Fig. 1-5c).

Figure 1-5 Wedge spectrograms. (© Eastman Kodak Co. 1976).

a. Monochromatic emulsion—sensitive to blue light only (400 Nm to 500 Nm).

b. Orthochromatic—sensitive to blue and green (400 Nm to 600 Nm).

c. Panchromatic—sensitive to blue, green, and red (400 Nm to 700 Nm).

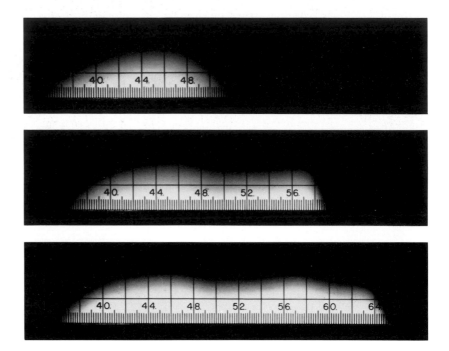

Photographic emulsions can be sensitized beyond the visible spectrum into the infrared range(700 Nm to 900 Nm), and photographs may be produced using only infrared as their exposing radiation (Fig. 1-6). Special applications of such emulsions include visual penetration of smog or fog, studies of living vegetation, and investigations of thermal pollution (Fig. 1-7). Because all photographic materials are sensitive to blue and shorter wavelengths, emulsions can record information within the ultraviolet and X ray portions of the spectrum. Ultraviolet photography helps in detecting forgeries (Fig. 1-8): the medical and nonmedical uses of X rays allow us to see into solid matter (Fig. 1-9).

Frequency. Another important measurement associated with electromagnetic waves is frequency, defined as the number of complete waves that pass a given point in one second. Light waves are impossible to count, so their frequency is determined with the following formula:

$$\text{Frequency} = \frac{\text{Speed of light}}{\text{Wavelength of the light}}$$

Figure 1-6 Infrared radiation as a source for the exposure of photographs. (Courtesy of Eastman Kodak Co.)

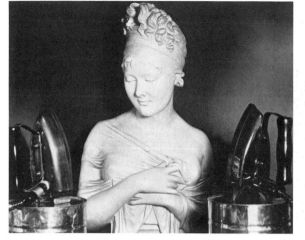

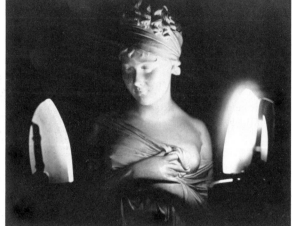

a. Normal photo using visible light as the exposing radiation.

b. Infrared photo using the infrared radiation emitted by the hot irons as the exposing radiation.

Figure 1-7 Infrared (IR) photography. With IR film we can penetrate the layer of haze present in the scene. Note the added detail in the infrared photo. (©Eastman Kodak Co. 1977)

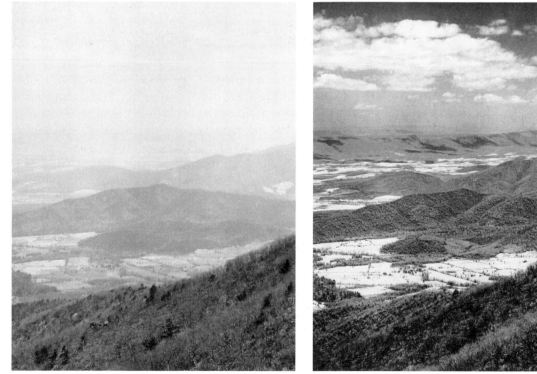

Normal

Infrared

Figure 1-8 Ultraviolet photography can help detect forgeries, as in the case of this altered will. The body of the original document was eradicated, leaving only the signature, above which new text has been typed. The result appears to be a proper will. (© Eastman Kodak Co. 1974)

a. Photograph of the document as it would appear to the human eye.

b. Ultraviolet photograph showing both the original and altered documents.

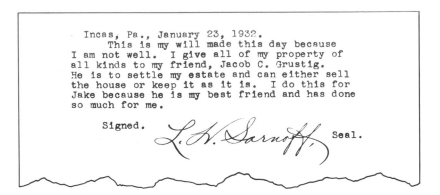

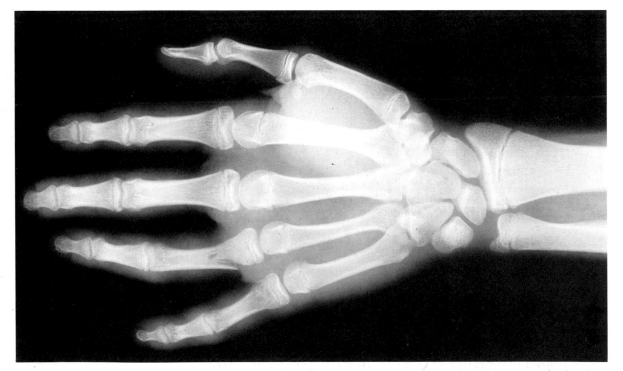

Figure 1-9 a. Medical Xrays allow us to see through skin and determine the extent of bone damage, as in this break of the ring finger.

Figure 1-9

b. Nonmedical uses of X ray photography include examining the internal components of a piece of equipment without having to dismantle it. This type of testing has saved industry large sums of money by shortening the downtime of the equipment under study.

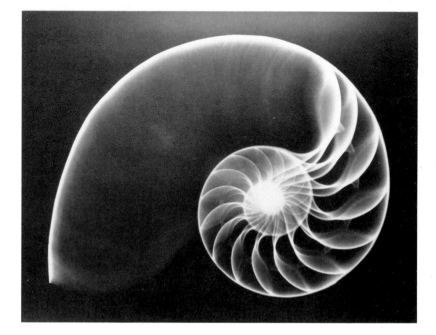

c. X rays can also produce creative and beautiful photographs, as in this image of a nautilus shell. (Courtesy of Eastman Kodak Co.)

Because the frequency of a given light wave remains the same regardless of the medium through which it passes, when light enters a denser medium, it slows down, and its wavelength decreases the same proportional amount. Likewise, when light enters a rarer medium, both its speed and wavelength increase the same proportional amount.

Rectilinear Propagation. When light leaves a luminous source, it travels in straight lines in all directions and will continue in a straight line through any homogeneous medium until the medium is changed. Light that strikes an object can be absorbed, reflected, or transmitted.

Absorption and Reflection

Light rays can be absorbed totally or selectively. **Selective absorption**—the absorption of only certain wavelengths—is the basis for filter theory (see Ch. 7).

Most of the light we perceive has been reflected from non-luminous surfaces. The characteristics of such reflected light depends on the nature of the surface from which it is reflected.

There are two kinds of reflection, specular and diffuse. **Specular reflection**—from smooth, flat surfaces such as water, glass, or a mirror—is always controlled by the following simple law of optics:

Angle of incidence = Angle of reflection

That is, a light ray is reflected from a surface at the same angle at which it reaches the surface. As the angle of incidence increases, so does the angle of reflection. These angles are measured from an imaginary line called the normal line, which is drawn perpendicular to the reflecting surface (Fig. 1-10).

Diffuse reflection occurs when the reflective surface is irregular. Because no single normal (perpendicular) line can be drawn to this kind of surface, the angles of incidence and reflection are impossible to measure and the reflected light is scattered and diffuse (Fig. 1-11).

Transmission

When a light ray travels from air into glass, its velocity always decreases as it enters this denser medium. If the ray strikes the glass along a line perpendicular (normal) to the surface, a small portion of the light is reflected back along its original line of travel, but the greater amount is transmitted through the glass in a straight line. Because glass is denser than air and the ray's velocity

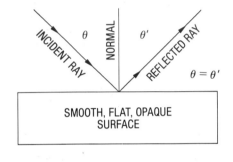

Figure 1-10 Specular reflection. The angles of incidence and reflection, measured from the perpendicular (normal) line, are always equal to each other.

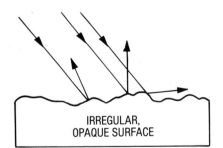

Figure 1-11 Diffuse reflection. Because no single normal line exists for an irregular surface, reflection is multidirectional and scattered.

decreases as it enters the glass, the wavelength must decrease the same proportional amount while the frequency of the light remains the same in both the air and the glass.

Refraction Through Parallel-Sided Glass

If a light ray strikes glass at an oblique angle, the light not only slows down but also changes direction; that is, one side of the ray slows down before the other side as it enters the glass, and the ray bends toward the normal line. This bending is called **refraction** (Fig. 1-12). If both sides of the glass are parallel, as the light leaves the glass, it will bend away from the normal and resume its original direction, offset by the amount of bending within the glass (Fig. 1-13). The angle of refraction depends on two things: the angle of incidence at the air-glass interface and the density of the refractive material (index of refraction). The greater the angle or the greater the density, the greater the amount of bending.

Critical Angle. Regardless of the entrance angle of incidence, the light ray will always enter the glass and bend toward the normal. Whether the light leaves the glass and goes back into the air, however, does depend on the exit angle of incidence. There is a **critical angle** at which or beyond which no light will leave the glass. The critical angle for an optical glass-air interface is 40°. If the light strikes the glass-air interface at less than 40°, it will exit the glass and bend away from the normal line. At exactly 40°, the light will bend so far from the normal that it will not escape the glass but will instead skim along the surface. If the critical angle is exceeded, the light will bend even farther from the normal to be reflected back into the glass. This internal reflection is specular in nature, so the angle of incidence will equal the angle of reflection (Fig. 1-14). Lens designers must take into account the critical angle

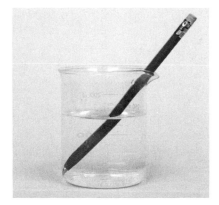

Figure 1-12 Refraction. The image of the pen is bent toward the normal line when it leaves the thinner medium (air) and enters the denser medium (water).

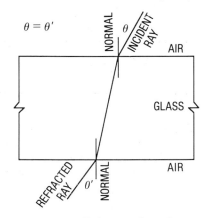

Figure 1-13 Refraction through parallel-sided glass. The incident angle equals the refracted angle (measured from the normal line).

Figure 1-14 Degree of refraction depends on the internal angle of incidence—the greater the angle, the greater the degree of bending away from the normal. When this angle is 40° or more, the light ray will bend so far away from the normal that it never leaves the glass. Instead, the ray will either skim along the air-glass interface (angle of incidence = 40°) or be reflected back into the glass (angle of incidence >40°).

LESS THAN 40°　— · — · —
EQUAL TO 40°　————————
GREATER THAN 40°　— — — —

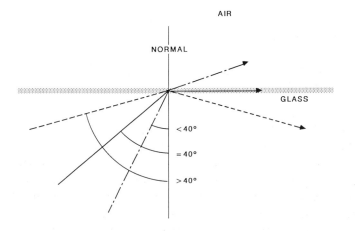

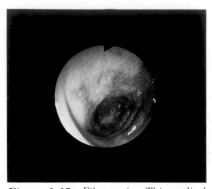

Figure 1-15 Fiber optics. This medical use of fiber optics displays views of the human digestive system. Pictures of this type help doctors determine if surgery is required.

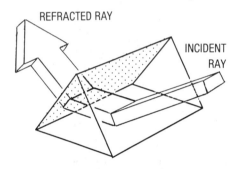

Figure 1-16 Refraction through non-parallel-sided glass. The transmitted light changes direction.

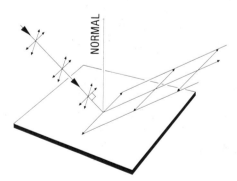

Figure 1-17 Polarization. When light that is vibrating in all directions is reflected from a non-metallic surface, the reflected rays become polarized in a direction parallel to the reflecting surface.

and shape of their products so that exiting rays always reach the glass-air interface at an angle smaller than 40°.

There are special optical systems designed to reach or exceed critical angle. One such system is **fiber optics**, which has been used successfully to see into areas otherwise inaccessible because of physical danger or spatial limitations. Images of internal organs, nuclear reactions, and other inaccessible sites travel through bundles of glass or plastic fibers that can be bent or twisted in knots. These images are then recorded at the receiving end with traditional photographic techniques (Fig. 1-15).

Refraction Through Non-Parallel-Sided Glass

Unlike refraction through parallel-sided glass, in which light resumes its original direction offset by the amount of refraction, when light travels through glass with nonparallel sides, its direction is changed, and it does not resume its original path. Take, for example, a glass prism: Light enters the glass, slows down, and bends toward the normal. As it leaves the glass, the light resumes its initial velocity and bends away from the normal, thus changing direction (Fig. 1-16).

Index of Refraction. Depending on its density, every medium bends light to a different degree. The degree of bending characteristic of a material is called the material's **index of refraction**. The higher the refractive index, the more the light is bent.

Dispersion. The index of refraction of a given material also depends on the wavelength of radiation involved. The shorter the wavelength, the higher the refractive index. Thus, when white light (which consists of all visible wavelengths) passes through a prism, each wavelength bends a different amount, and the light emerges spread out in a fan shape. If the light is then projected onto a surface, all the colors of the spectrum will appear, a phenomenon known as dispersion (Fig. 1-4a). Dispersion can create a serious optical problem—chromatic aberration (see Ch. 2).

Polarized Light

Light vibrates in all directions perpendicular to the direction of wave travel. A simple analogy is a bicycle wheel: As a given point on the wheel hub moves forward, the path it takes has the form of a wave. The direction of travel is forward in the direction of the wave, and the light travels outward in the direction of the spokes of the wheel (Fig. 1-17). If light waves are reflected from a smooth, flat, nonmetallic surface, only the vibrations parallel to the surface are reflected, and the reflected light has become polarized. Such polarized light is specular in nature and may be a source of glare

light, such as the sun's reflection from water or a window (Fig. 1-18). The photographic significance and control of polarized light are discussed in Chapter 7 under "Special-Purpose Filters."

Figure 1-18 Polarized glare from water. The polarized glare in this photo adds to its overall composition. However, if the glare is distracting to the final print, it may be reduced or removed by a polarizing filter (see Ch. 7).

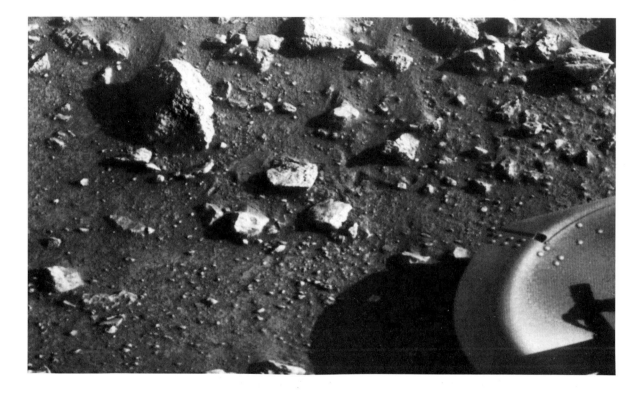

Figure 1-19 First photograph ever taken of the surface of Mars, obtained by an Itek electro-optical camera just minutes after Viking I landed on July 20, 1976. The image was transmitted more than 220 million miles through space. (Courtesy of Itek).

Chapter 2

Basic Optics

Because light travels in straight lines (rectilinear propagation), an image can be formed when light passes through any aperture. Early photography's **camera obscura** made use of this phenomenon. The first models of camera obscura had a pinhole rather than a glass lens for focusing light and left no permanent photographic record (Fig. 2-1). Because a pinhole does not produce a bright, sharp image, the camera obscura was not suited to the early experiments in permanent photographic processes. Attempts to make the image brighter by enlarging the pinhole failed because the image became less sharp. Narrowing the aperture to sharpen the image also failed because of the phenomenon of diffraction (see Chp. 1). Eventually, pinholes were replaced with lenses made of optical-quality glass or plastic because they produce brighter, sharper images.

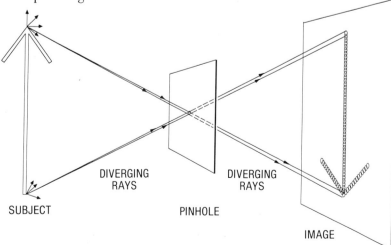

Figure 2-1 When light rays pass through a pinhole, they continue to diverge and form images that are made of circles rather than points.

Lenses

As we learned in Chapter 1, light is refracted *toward* the normal as it passes obliquely from a rare medium (air) into a denser medium (glass). As it leaves the denser medium, the light is bent *away from* the normal. Thus, if the sides of the denser medium are parallel, the rays of light emerge offset but moving in the original direction (see Fig. 1-13, p. 9). If the sides of the denser medium are not parallel, as is the case with a glass prism, the rays actually change direction (see Fig. 1-16, p. 10).

Simple Lenses

A simple glass lens is shaped from a block of optical-quality glass into a single-element disc with non-parallel, spherical surfaces. This kind of lens acts like many prisms stacked together in that it refracts all transmitted light to a common point (Fig. 2-2).

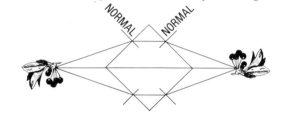

Figure 2-2 The simple lens acts like several prisms stacked together. These three drawings depict how the edges of such a composite prism are smoothed to form a lens. Because light rays from a point are refracted to a common point, the simple lens is capable of producing sharp images.

Converging (Positive) Lens and Diverging (Negative) Lens. Simple lenses come in two varieties, converging and diverging. The **converging lens**, also called a **positive lens**, is thicker in the center than at the edges (Fig. 2-3). Such a lens bends light rays to a common point and thus is capable of forming photographic images by itself.

Figure 2-3 Converging lenses are thicker in the center than at the edges.

Bi-convex Plano-convex Meniscus

The **diverging lens**, also called a **negative lens**, is thicker at the edges than at the center and is incapable of forming photographic images by itself (Fig. 2-4). However, negative lenses can be combined with more powerful positive lenses into a lens system that is capable of producing images.

Bi-concave Plano-concave

Figure 2-4 Diverging lenses are thicker at the edges than at the center.

Focal Length

Any positive lens or positive lens system can be given a mathematical value called **focal length** (FL). Parallel rays of light will focus behind a positive lens at a common point called the **principal focus** or **focal point**. The distance from this point to the rear nodal point of the lens is the lens' focal length (Fig. 2-5). The greater the converging power of the lens, the smaller the image, the shorter the focal length, and the greater the angle of coverage.

Because lenses of different focal lengths can yield markedly different images, we must define a normal focal length for a camera-film combination. A lens of **normal focal length** should give the same angle of coverage (approximately 46°) and the same magnification and perspective as the human eye viewing from the same point. It would be quite cumbersome to determine normal focal length for every possible combination of film size and camera format, so an alternate definition has been formulated: Normal

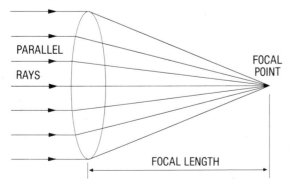

PARALLEL

RAYS

FOCAL POINT

FOCAL LENGTH

Figure 2-5 A lens' focal length is measured from the rear nodal point of the lens (optical center in a single lens system) to the focal point.

focal length equals the diagonal width of the film format being used. For example, normal focal length for 35mm film (24mm x 36mm) is roughly 50mm (Fig. 2-6).

Figure 2-6 Normal focal length for a lens is the same measurement as the diagonal width of the image area. For example:

a. 35-mm film normal focal length is 50 mm.

b. 120, 12-exposure roll film (2¼" x 2¼") normal focal length is 80mm.

c. 4 in. x 5 in. (100mm x 125mm) sheet film normal focal length is 162mm.

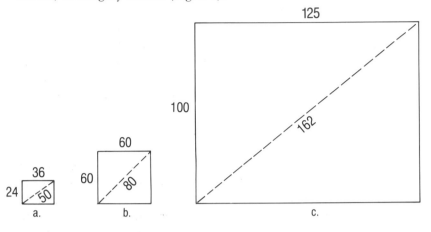

DRAWING IS IN PROPORTION BUT NOT TO SCALE.

Figure 2-7 Lens systems.

a. Normal-focal-length lens.

b. Telephoto or long-focal-length lens. The addition of a negative lens element acts to increase the focal length.

c. Wide-angle or short-focal-length lens. The addition of a positive lens element shortens the focal length of the lens.

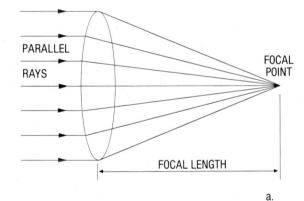

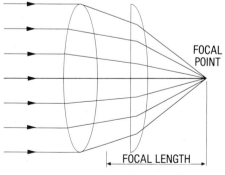

The focal length of a lens can be increased by adding more negative power to the lens system. Such a lens system is called a **telephoto** or **long-focal-length lens** (Fig. 2-7b). For a given subject distance, the greater the focal length, the narrower the angle of coverage of the lens and the larger the image.

Focal length can be shortened by adding more positive power to the lens system. Such a lens system is called a **wide-angle lens** (Fig. 2-7c). For a given subject distance, the shorter the focal length, the wider the angle of coverage of the lens and the smaller the image.

Accessory Lenses

Many modern cameras allow removal of the regular lens so that lenses of different focal lengths can be attached to achieve specific effects. The three main types of accessory lenses are the telephoto lens, the wide-angle lens, and the zoom lens. Because of the extra lens elements needed to create these lenses, they can prove to be much more expensive than normal-focal-length lenses of similar quality.

Telephoto or Long-Focal-Length Lens. Telephoto lenses have focal lengths greater than the diagonal of their image and will therefore affect the perspective and angle of coverage of the photograph. The physical constraints of a photographic situation often do not allow the photographer to get in the right position for a desired shot. At times it can even be dangerous. A telephoto lens may be useful in such a situation (Fig. 2-9). Because image size increases and angle of coverage decreases as focal length is increased, the apparent perspective of the image is also changed. As the focal length of the lens is increased, distance appears compressed, giving the impression of less depth between various components of the scene. This apparent foreshortening can be used to advantage or, if disregarded, can decrease the value of an image (Fig. 2-10). The apparent image magnification will also magnify camera movement. Use of a tripod or some camera support becomes important when a telephoto lens is employed.

As telephoto lenses become very long in focal length, their bulk and weight become a problem. Mirror (catoptric) lenses adapt very well to extremely long focal lengths without some of the problems encountered with normal telephoto design (Fig. 2-8). The mirror lens's folded optics design allows for a short overall length with less weight than a standard lens of the same focal length. It is this folded optics design, however, that causes one of the major problems in mirror lenses. Because the front element is partially blocked by the secondary mirror, the relative aperture of mirror

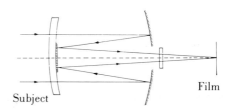

Figure 2-8 Mirror optics. Light enters through a large corrector plate and is converged by the rear primary mirror to a secondary mirror coated on the inside of the corrector plate. The light is then reflected through a hole in the primary mirror to the film.

lenses is quite wide (F/6.3–F/8). Another severe problem with this type of lens is that no aperture can be included within the lens to limit the intensity of light passing through the lens. Exposure is therefore controlled by colorless neutral density filters that limit the amount of light passed through the lens (see Ch. 7, "Special-Purpose Filters").

Wide-Angle or Short-Focal-Length Lens. A lens with a shorter focal length than the diagonal of its image is called a wide-angle lens. When a photographer is unable to back up far enough

Figure 2-9 Telephoto photograph. The subject in this scene could not be approached because of a fence. Only the use of a telephoto lens allowed for a properly composed photograph. (Courtesy of Donald B. Rex)

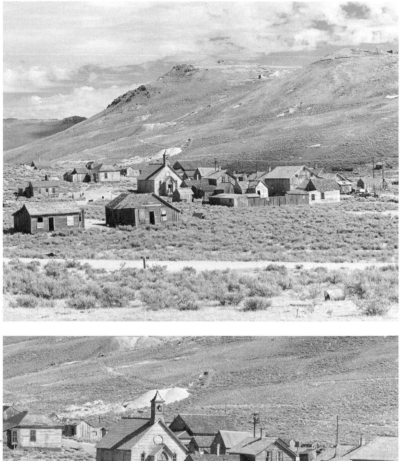

Figure 2-10 Compression and field reduction with a telephoto lens. In this telephoto picture of Bodie, California, the apparent distance between foreground and background is compressed while overall image area is decreased.

Normal

Telephoto

to include all of a desired subject in the field of view of a normal-focal-length lens, the lens can be replaced with a wide-angle lens, which will expand the field of view enough to include all the desired components of the image (Fig. 2-11). Because image size

Normal

Wide-angle

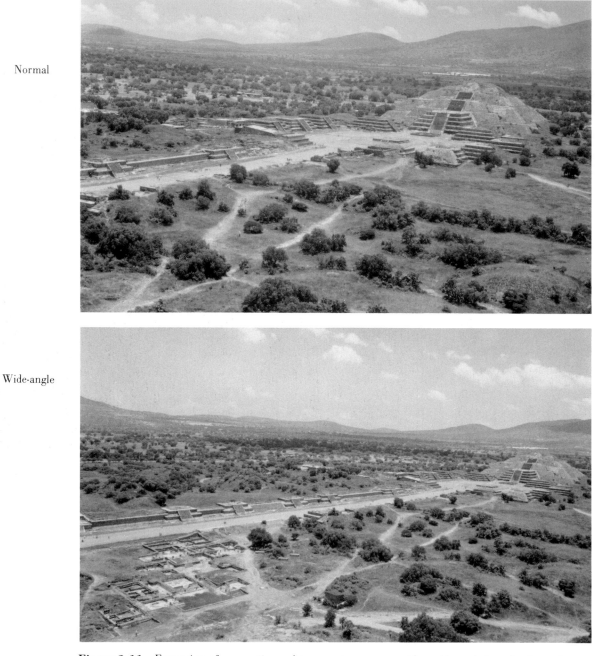

Figure 2-11 Expansion of perspective and increase in coverage with a wide-angle lens. In these pictures taken from the Pyramid of the Sun near Mexico City, the apparent distance between foreground and background seems to be increased with the wide-angle lens; overall image area is increased as well.

decreases and angle of coverage increases as focal length is decreased, the apparent perspective of the image is also changed. The effect of a wide-angle lens is opposite to that of a telephoto lens: Distances between components of the image seem to increase as focal length is decreased, making a foreground object appear much larger than a background object. This effect can be either creative or disastrous (Fig. 2-12).

Figure 2-12 Wide-angle distortion.

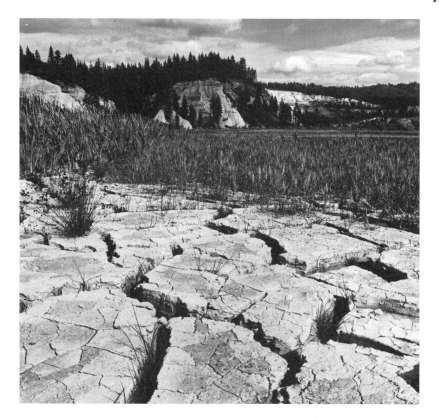

a. Wide-angle distortion of the foreground is highly effective in this picture of the mud flats surrounding the Malakoff Diggings in the Mother Lode Country of California.

b. To avoid serious distortion, never use a wide-angle lens for portraiture.

Zoom Lens. The zoom or variable-focal-length lens has become very popular in recent years. The zoom lens has movable elements or groups of elements, to vary its focal length within a specific range (Fig. 2-13). Zoom lenses give the advantage of replacing all the lenses within their zoom range. They are also a great aid to composition because the zoom lens may be moved to the correct focal length for the best picture of a given subject without the necessity of movement on the part of the camera and photographer. Many zoom lenses allow for a macro range of focus for extreme close-ups. Although zoom lenses do have many advantages, they usually do not produce images of equal sharpness as a high-quality fixed-focal-length lens.

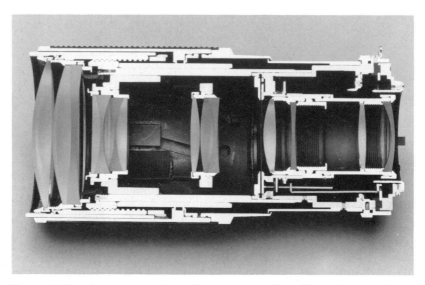

Figure 2-13 Cutaway view of a modern zoom lens. The additional movable lens systems needed for variable focal length add to the cost. (Courtesy of Vivitar Corporation)

Effect of Focal Length on Image Size

When a lens is focused on a distant subject, the height and width of the image will be directly proportional to the focal length of the lens. For example, an image from a 100mm lens is twice the height and width of an image from a 50mm lens. Because image height and width double when focal length is doubled, the area of the image is directly proportional to the square of the focal length (FL)2 (Fig. 2-14).

Figure 2-14 Field of view decreases proportionally with increasing focal length. Magnification increases proportionally with increasing focal length. For this series of photographs, the stationary camera was mounted on a tripod and each exposure taken with a lens of a different focal length. Notice the resulting differences in both field of view and magnification. (Courtesy of Minolta Corporation)

7.5mm wide-angle lens

16mm wide-angle lens

28mm wide-angle lens

35mm wide-angle lens

50mm normal-focal-length lens

100mm telephoto lens

200mm telephoto lens

800mm telephoto lens

Depth of Field and Depth of Focus

Even though a lens can produce a perfectly focused image in only one plane, a photograph will display a *region of apparent focus* from in front of the main plane of focus to behind it. The region of apparent focus in front of the lens (subject side of the lens) is called **depth of field** and is divided approximately one-third in front of the main plane of focus and two-thirds behind (Fig. 2-15). The region of apparent focus on the image side of the lens is called **depth of focus**.

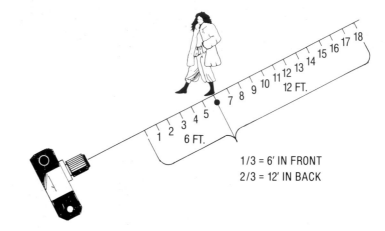

Figure 2-15 Depth of field is a region of focus that extends from 1/3 of its total distance in front of the subject to 2/3 of its distance behind the subject. In this example, the total depth of field of 18 feet is divided into 6 feet in front of the subject and 12 feet behind.

That there is a region rather than a sharp plane of focus is a consequence of a certain unsharpness in the resolving power of the human eye as it perceives the photographic image. All lenses actually reproduce points as circles. These circles appear sharp to the eye as long as they do not exceed an arbitrary size called the **circle of confusion**, which for a 10-inch viewing distance is one-hundredth of an inch in diameter.

Both depth of field and depth of focus are a function of three things—aperture size, focal length, and subject distance.

Aperture Size. As aperture size is decreased, there is an increase in both depth of field and depth of focus (Fig. 2-16). The increase in aperture-controlled depth of field is limited, because very small apertures create diffraction and, hence, unsharp images. However, most modern lenses are diffraction limited; that is, they are designed in such a way that apertures that are too small cannot be used.

Focal Length. As focal length is decreased, both depth of field and depth of focus increase (Fig. 2-17). At a given aperture, the shorter the focal length, the greater the depth of field.

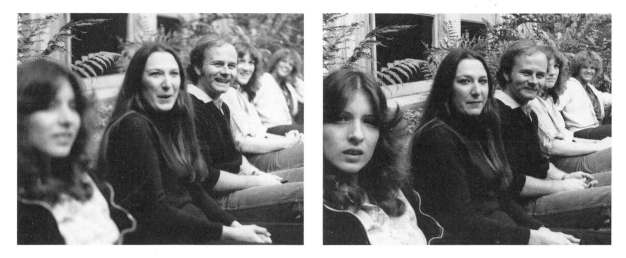

F/4 F/22

Figure 2-16 Depth of field as a function of lens aperature size. If you keep focal length and subject distance the same while decreasing aperture size, the depth of field increases. (Courtesy of Donald B. Rex)

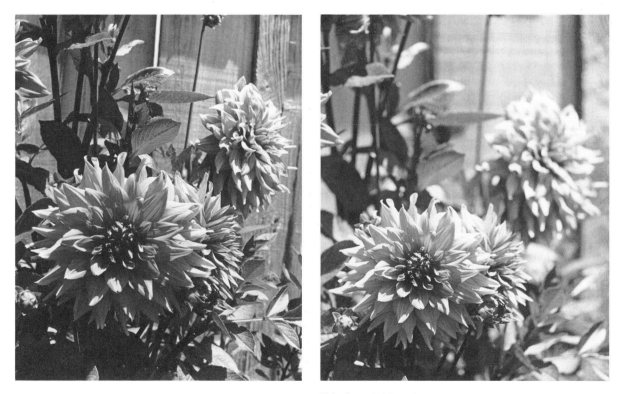

Wide-angle (25 mm) Telephoto (200 mm)

Figure 2-17 Depth of field as a function only of lens focal length. If you keep aperture and subject distance the same while decreasing the focal length, the depth of field increases.

Figure 2-18 Depth of field as a
function only of subject distance. If you
keep aperture and focal length the same
while increasing the distance from the
camera, the depth of field increases.
(Courtesy of Donald B. Rex)

Nearby subject

Distant subject

Subject Distance. As subject distance increases, there is an
increase in both depth of field and depth of focus (Fig. 2-18). With
a given focal length and aperture, the greater the distance between
lens and subject, the greater the depth of field.

A photographer can manipulate depth of field to advantage. A
large depth of field is desirable in some pictures but can detract
from the composition in others. For maximum depth of field the
photographer should use a wide-angle lens, a narrow aperture, and
a longer distance to subject (Fig. 2-19). To achieve minimum depth
of field it is wise to use a telephoto lens, a wide aperture, and a
shorter distance to subject (Fig. 2-20).

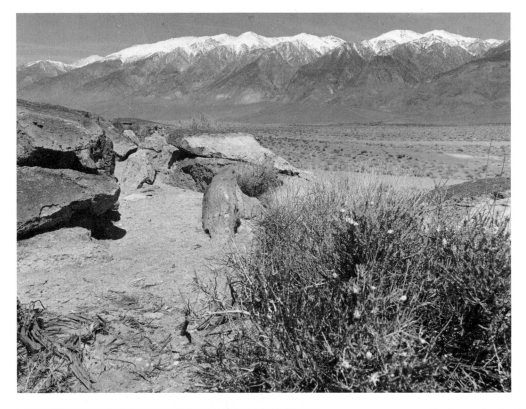

Figure 2-19 Maximum depth of field. A wide-angle lens was combined with a small lens aperture (F/22) and a large camera-to-subject distance to produce this photograph with extreme depth of field.

Figure 2-20 Minimum depth of field. A telephoto lens was combined with a large aperture (F/2.8) and a small subject-to-camera distance to produce this photograph with minimum depth of field.

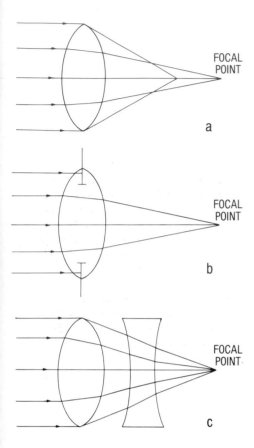

Figure 2-21 Spherical aberration.

a. The single lens is unable to focus all light rays at a common point.

b. Inexpensive correction. Placing a smaller aperture in the path of light prevents the out-of-focus rays from reaching the film.

c. Expensive correction. Adding a negative lens corrects spherical aberration without decreasing the maximum aperture of the lens.

Lens Aberrations

Five basic aberrations or image errors prevent a single-element lens from producing a perfect image: spherical aberration, coma, astigmatism, field curvature, and chromatic aberration. Overcoming these aberrations so as to produce high-quality images requires the use of a many-elemented system.

Spherical Aberration. When a cone of light rays passes through a simple convex lens, not all the rays are brought to the same focal point. Instead, the rays that go through the outer zone of the lens are refracted more than those passing through the inner zone, thus bringing them to focus too near the lens. This phenomenon is known as **spherical aberration** (Fig. 2-21a).

Spherical aberration can be corrected in two ways. In the first method (used in box-type cameras because of its low cost), an aperture is placed in the lens, allowing through only the image-forming light rays from the good, inner zone of the lens (Fig. 2-21b). High-quality cameras do not use such a device because it makes inefficient use of the lens. Instead they add to the system a negative lens with a spherical aberration of the same magnitude as the positive lens but opposite in direction. This acts to bend the outer rays back again and directs them to the common focal point (Fig. 2-21c).

Some special portrait lenses do not correct spherical aberration. When these lenses are used with a wide-open aperture, the resultant image is not critically sharp. This adds a pleasing soft effect to a portrait. As the aperture in these lenses is decreased, the effect of the spherical aberration is negated, as in the case of the box camera.

Coma. Coma is a kind of spherical aberration that occurs only when the subject is not in direct line with the lens. Coma causes the image of a point to fan out like a comet, with a bright core and a one-sided tail. The marginal rays having a different focal length from the principal ray causes this coma effect (Fig. 2-22). Coma is corrected in the same ways as spherical aberration.

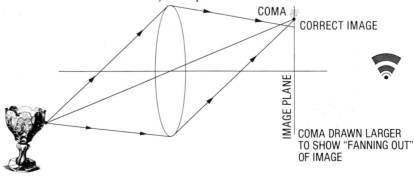

Figure 2-22 Coma is an off-axis spherical aberration. Edge rays converge too sharply and are not in focus. The image of a dot becomes elongated and fuzzy.

Astigmatism. Astigmatism is the inability of a lens to sharply focus both the vertical and horizontal planes at the same time. Due to unequal refraction of the marginal rays, two planes of focus are set up, one for the horizontal plane and one for the vertical (Fig. 2-23). Astigmatism is corrected with an **anastigmatic lens,** in which the aperture separates some of the lens elements (Fig. 2-24). This separation need not be optically symmetrical.

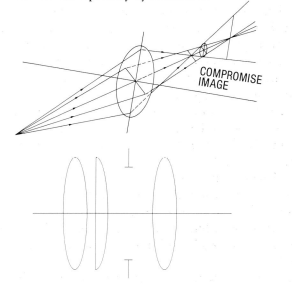

COMPROMISE IMAGE

Figure 2-23 Astigmatism. No single lens can focus both the horizontal and vertical components of an image at the same point. Images in front of the compromise image are horizontal images; those formed behind the compromise image are vertical images.

Figure 2-24 Anastigmatic lens. Separating lens elements corrects for astigmatism. The negative lens in this drawing will correct for spherical aberration and coma.

Field Curvature. The inability of a lens to create an image of a three-dimensional subject on a two-dimensional surface produces **field curvature** (Fig. 2-25). Early box cameras corrected for this aberration by curving their film plane. Modern anastigmatic lenses will correct for field curvature.

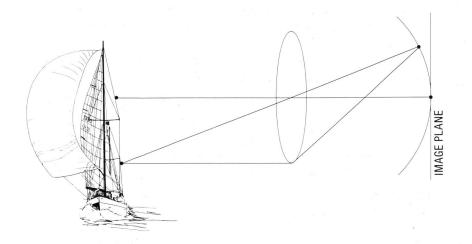

IMAGE PLANE

Figure 2-25 Field curvature arises from the inability of a single-element lens to produce sharp images edge to edge on a flat imaging surface.

Chromatic Aberration. The inability of a lens to have a common focal point for all wavelengths of light produces **chromatic aberration**. In the Chapter 1 discussion of dispersion, we learned that the refractive index of glass varies with the wavelength of the light transmitted so that each color is focused at a different point, with the shorter wavelengths refracted to a point nearer the lens (Fig. 2-26). At the focus for blue light, the image is surrounded by a halo of green and red; at the focus for red, there is a halo of blue and violet. Thus, at no time is the image sharp except for light of one color. Chromatic aberration is corrected by the use of a negative glass lens with a higher refractive index than the positive lens. This negative lens is cemented to the positive lens to form a compound lens. Dispersion through the negative lens cancels dispersion through the positive lens for two wavelengths without destroying converging power.

Figure 2-26 Chromatic aberration stems from the inability of a single-element lens to focus all wavelengths at the same point. Shorter wavelengths (blue) will converge closer to the lens than will longer wavelengths (red).

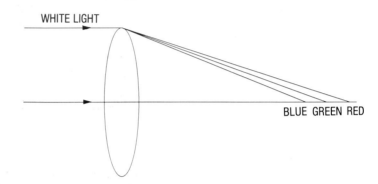

Lens Distortions

Lens distortion is a change in magnification with field angle that distorts the shape of an image. It can be corrected by employing a lens of symmetrical design.

Pincushion Distortion and Barrel Distortion. When a camera's diaphragm is *behind* the lens, magnification is greater for the marginal portions of the image. This is known as **positive** or **pincushion distortion** (Fig. 2-27). When a camera's diaphragm is *in front* of the lens, magnification decreases with distance from the axis, producing **negative** or **barrel distortion** (Fig. 2-28).

Lens Coating

The modern lens is coated on its air-to-glass surfaces with magnesium fluoride in order to reduce lens flare or unwanted, non-image forming light from striking the film. Coating each air-glass interface with fluorides to a thickness of one-fourth the wavelength of green light (550/4 = 137.5 Nm) greatly increases the transmissibility of the lens. The coating is applied and then is evaporated off

so that it is thinner than desired. More coats are applied until the required 137.5 Nm thickness is achieved. This multi-coating technique produces superior results to one single coat of magnesium flouride.

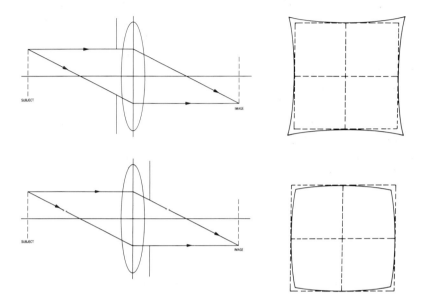

Figure 2-27 Pincushion (positive) distortion. This image of a square is enlarged and distorted due to a single lens element placed behind the aperture.

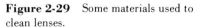
------- CORRECT IMAGE
———— DISTORTED IMAGE

Figure 2-28 Barrel (negative) distortion. This image of a square is reduced and distorted due to a single lens element placed in front of the aperture.

Cleaning Lenses

Photographic lenses are precision instruments and should be treated with care. They should be cleaned only with materials designed especially for optical lenses (Fig. 2-29). All abrasive material should first be carefully removed from the lens surface with a clean camel's hair brush or blower. Humidity should then be breathed onto the lens surface and carefully wiped off with photographic lens-cleaning tissue, working from the center to the outside in soft, circular motions. Lens-cleaning solvent can be applied to the tissue if humidity alone does not remove the blemish. Never rub an optical surface with any great pressure—this precaution will protect against serious, image-damaging scratches.

Figure 2-29 Some materials used to clean lenses.

Figure 2-30 Tioga Pass. Camera: 1/125 F/16. Print: 11 seconds F/16.

Chapter 3
Optical Image Formation

As we learned in Chapter 2, a positive lens refracts parallel rays of light to a common point called the principal focus (see Fig. 2-5, p. 15). This bending power of a positive lens, combined with the fact that light unobstructed wants to travel in straight lines (rectilinear propagation), enables a lens to form images.

Image Size

Optical image formation follows the law of similar triangles in geometry. To show how a lens produces an image, we speak of two different types of light rays: the **principal** or **axial rays**, which pass undeviated through the optical center of the lens, and the **parallel rays**, which refract and converge through the principal focus of the lens (Fig. 3-1).

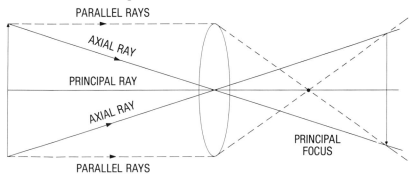

PARALLEL RAYS

AXIAL RAY

PRINCIPAL RAY

AXIAL RAY

PRINCIPAL FOCUS

PARALLEL RAYS

Figure 3-1 Image formation diagrammed with parallel and axial rays. A careful check of the diagram displays how the top of the subject becomes the bottom of the image. An image formed by a lens is always inverted.

 Reduced Image. The most common type of photographic image is the **reduced image**, that is, an image smaller than its subject (magnification less than 1). A reduced image is created when the

subject is located more than two focal lengths in front of the lens (for example, over 100mm (4 in.) from a lens with a focal length of 50mm (2 in.). The resultant image will fall between one and two focal lengths on the other side of the lens—in our example, between 2 and 4 inches (Fig. 3-2). In the special case of a subject located at "infinity" (for instance, a star), the image will form exactly at the principal focus of the lens.

Natural-Size Image. As a subject moves closer to the lens, the image of that subject moves away from the lens and also increases in size. If the photographer wants the image on the negative to have exactly the same size as the subject (**natural size**, or magnification = 1), the subject should be located exactly two focal lengths in front of the lens. The image formed from this configuration will fall exactly two focal lengths behind the lens. With a lens of focal length of 2 inches, for example, both subject and image must be 4 inches from the lens to be identically sized (Fig. 3-2).

Enlarged Image. To produce an **enlarged image** (larger than the subject, or magnification greater than 1), the lens must be located less than two focal lengths but more than one from the subject. (With our 2-inch focal length lens, that means less than 4 inches but more than two (Fig. 3-2). With the subject located between one and two focal lengths from the lens, the image would fall more than two focal lengths behind the lens (farther than 4 inches from our 2-inch focal length lens).

Figure 3-2 Image formation and image size. All images form at or beyond one focal length and are inverted (upside down).

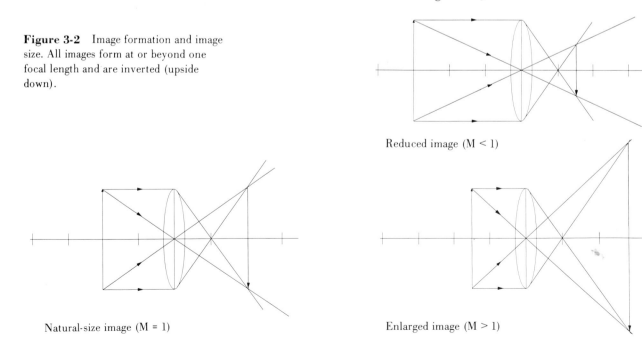

Reduced image (M < 1)

Natural-size image (M = 1)

Enlarged image (M > 1)

When a Positive Lens Will Not Form an Image

Because of the nature of a positive lens and the laws of geometry, there are three conditions under which an image will not form:

1. When there is less than four focal lengths total between subject and image. Reviewing the examples of reduced, enlarged, and natural-size images will confirm that both reduced and enlarged images fall more than four focal lengths from the subject. Only natural-size images (M = 1) are exactly four focal lengths from their subject.

2. When the subject is one focal length or less from the lens. When a subject is located one focal length or less from the lens, rather than coming to a common point to form an image, the rays of light will emerge from the lens either parallel or divergent (Fig. 3-3).

3. When the imaging surface is closer to the lens than one focal length. Because parallel rays of light converge at the principal focus of a lens, there can be no convergence in front of this point. No convergence, no image.

Figure 3-3 No image can form when a subject is located one focal length or less from the lens. Instead, all rays leave the lens either parallel or divergent.

Algebraic Determination of Image Data

Knowing subject size and location and lens focal length, we can determine size, location, and magnification of the image in most photographic situations with two simple algebraic equations:

$$\frac{1}{\text{Subject Distance}} + \frac{1}{\text{Image Distance}} = \frac{1}{\text{Focal Length}}$$

or $\quad \dfrac{1}{\text{SD}} + \dfrac{1}{\text{ID}} = \dfrac{1}{\text{FL}}$

$$\frac{\text{Image Size}}{\text{Subject Size}} = \frac{\text{Image Distance}}{\text{Subject Distance}} = \text{Magnification}$$

or $\quad \dfrac{\text{IS}}{\text{SS}} = \dfrac{\text{ID}}{\text{SD}} = \text{M}$

For example, with a subject distance of 6 inches, a subject size of 10 inches, and a lens focal length of 2 inches, the equations give the following values for image distance, image size, and image magnification:

$$\frac{1}{\text{SD}} + \frac{1}{\text{ID}} = \frac{1}{\text{FL}} \qquad\qquad \frac{\text{IS}}{\text{SS}} = \frac{\text{ID}}{\text{SD}} \qquad\qquad \text{M} = \frac{\text{ID}}{\text{SD}}$$

$$\frac{1}{6} + \frac{1}{\text{ID}} = \frac{1}{2} \qquad\qquad \frac{\text{IS}}{10} = \frac{3}{6} \qquad\qquad \text{M} = \frac{3}{6}$$

$$\frac{1}{\text{ID}} = \frac{1}{2} - \frac{1}{6} \qquad\qquad \frac{\text{IS}}{10} = \frac{1}{2} \qquad\qquad \text{M} = \frac{1}{2}$$

$$\frac{1}{\text{ID}} = \frac{3}{6} - \frac{1}{6} \qquad\qquad \text{IS} = \frac{10}{2}$$

$$\frac{1}{\text{ID}} = \frac{2}{6} \qquad\qquad\qquad \text{IS} = 5 \text{ in.}$$

$$\text{ID} = \frac{6}{2}$$

$$\text{ID} = 3 \text{ in.}$$

Using these formulas, we can confirm the rules for natural-size images, reduced images, and enlarged images, which were discussed earlier. Thus, whenever subject distance or image distance is exactly two focal lengths, the image will be natural size. For a focal length of 2 inches and subject distance of 4 inches, we get:

$$\frac{1}{SD} + \frac{1}{ID} = \frac{1}{FL} \qquad\qquad M = \frac{ID}{SD}$$

$$\frac{1}{4} + \frac{1}{ID} = \frac{1}{2} \qquad\qquad M = \frac{4}{4}$$

$$\frac{1}{ID} = \frac{1}{2} - \frac{1}{4} \qquad\qquad M = 1$$

$$\frac{1}{ID} = \frac{1}{4}$$

$$ID = 4 \text{ in.}$$

For a **natural-size** image, then, M = 1, IS = SS and ID = SD.

When subject distance is more than twice the focal length, a reduced image will fall between one and two focal lengths behind the lens (between 2 and 4 inches with our 2-inch-focal-length lens). For a **reduced image**, M<1, IS<SS, and ID<SD.

When subject distance is less than two but greater than one focal length, an enlarged image will fall more than two focal lengths behind the lens (beyond 4 inches with our 2-inch-focal-length lens). For an **enlarged image**, M>1, IS>SS, and ID>SD.

Geometric Determination of Image Data

Because optical image formation follows the law of similar triangles, we can also use geometry to determine direct relationships between subject data and image data. Figure 3-4 shows how to do this when we know subject distance, subject size, and focal length. (Such information is usually available when the photographer is in the field.)

The principal axis in Figure 3-4 is divided into units of one focal length. The number of focal lengths in the subject distance is shown above the principal axis on the **subject side** of the lens. In this case, SD = 6 inches and FL = 2 inches, so there are SD/FL = 6/2 = 3 focal lengths in the subject distance. Notice that these 3 focal lengths are divided into 2 + 1. We have marked the principal axis in this way to highlight the number of focal lengths in *excess* of one. It is necessary to determine the number of focal lengths in excess of one, because in order to form an image, a subject must be more than one focal length

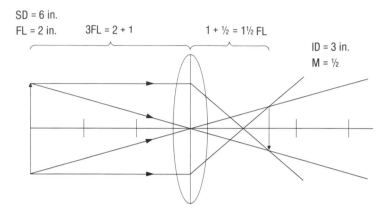

SD = 6 in.
FL = 2 in. 3FL = 2 + 1 1 + ½ = 1½ FL

ID = 3 in.
M = ½

Figure 3-4 Geometric determination of
image data.

in front of the lens. In this case, the subject is two focal lengths
beyond the minimal one.

As for the **image side** of the lens—remembering that light passed
through a lens forms an image that is inverted, it is logical to assume
that 2 focal lengths on the subject side of the lens should become ½
focal length (or the inverse of 2/1) on the image side. Notice in Figure
3-4 that image distance is divided into 1 + ½ in excess. No image can
form closer than one focal length behind the lens, and we want to
know the number of focal lengths in the image distance *beyond* the
minimal one.

We want to know the number of image distance focal lengths in
excess of the minimal one because this number represents the
magnification of the image. In our example, M = ½. To calculate image
data, we need only multiply subject data by magnification. That is,
IS = SS x M and ID = SD x M. In our example, IS = 10 in. x ½ = 5 in.
and ID = 6 in. x ½ = 3 in. Another example of this geometric method
may be found in Figure 3-5.

The geometric method for determining magnification is also of use
when figuring how much to change exposure when image magni-
fication is 1 or greater than 1. This topic is discussed fully in Chapter 5
under "Exposure Change, Image Magnification, and Bellows Factor."

SD = 12 in.
SS = 9 in.
FL = 3 in. 4FL = 3 + 1 1 + 1/3 = 1 1/3FL

ID = 4 in.
IS = 3 in.
M = 1/3

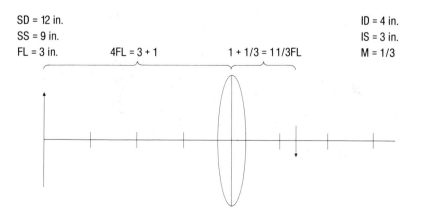

Figure 3-5 A further example of
geometric determination of image data.

Chapter 4
The Camera

A simple camera has four basic features: a light-tight box, a pinhole or lens for gathering light, a means for holding film, and a cap or shutter for limiting the duration of exposure. Advanced cameras have these same basic features but refined and with the option for numerous accessories (Fig. 4-1). This chapter will explain the four basic features of the camera and will discuss some of the many available types of cameras.

Figure 4-1 Cutaway view of modern highly refined 35-mm SLR camera (Courtesy of Nikon, Inc.). Electronics combined with mechanical design make this camera automatic and easy to use. In either automatic or manual mode, the camera can create numerous effects of high quality.

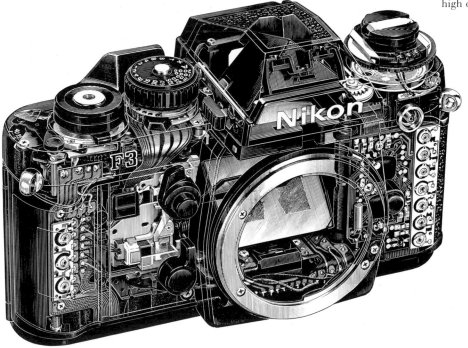

Light-Tight Box

Light-tight camera bodies are of two types: viewfinder and reflex. Regardless of type, the light-tight box ensures that only image-forming light will strike the film.

Viewfinder Camera. The first cameras all used a viewfinder body. Today, all inexpensive box cameras and certain more expensive cameras are of the viewfinder type (Fig. 4-2).

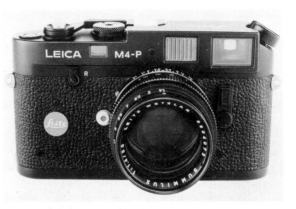

Figure 4-2 Leica M4-P viewfinder camera. (Courtesy of E. Leitz, Inc., Rockleigh, New Jersey)

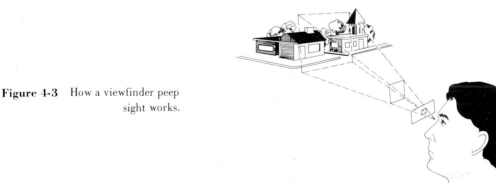

Figure 4-3 How a viewfinder peep sight works.

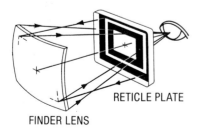

Figure 4-4 Albada finder.

The viewing system of the viewfinder camera is separate from its optical-imaging system. The simplest viewfinder consists of a frame with a peep sight at the rear for positioning the eye (Fig. 4-3). The typical viewfinder has a front negative lens that forms an erect, laterally correct (not backwards) image focused through a rear positive lens. On the **Albada finder**, the inner surface of the front concave lens is silvered; the rear lens has a finder frame on its surface. The silvered surface acts like a mirror, so the frame seems to float in space (Fig. 4-4).

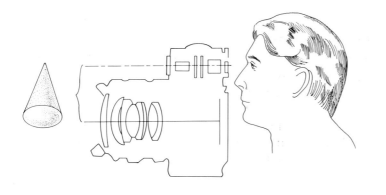

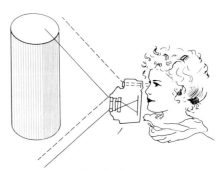

Figure 4-5 Viewfinder camera and parallax. In the viewfinder camera, there are two distinct light paths, one for the viewer (dashed lines) and one for the film image (solid lines). This disparity creates the problem of parallax, especially with a short subject-to-camera distance.

There are many advantages to the viewfinder camera. It is typically light, quiet, compact, and fast handling. Because the viewfinder camera commonly has fewer moving parts than more complex body styles, it is usually more reliable. The viewfinder system also produces a brighter viewing image, even at the moment of exposure, and thus allows more accurate focusing under low levels of illumination.

Parallax. The separate viewing system on all viewfinder cameras creates a major problem called **parallax**. Because the viewfinder and the imaging lens are in laterally different planes, they do not cover exactly the same area (Fig. 4-5). Parallax in a viewfinder camera can be corrected, as in the Leica family of cameras, but to do so is extremely expensive.

Reflex Camera. The reflex body was designed to help alleviate the problem of parallax by producing a viewing image reflected from a mirror. There are now two basic styles of reflex camera—twin lens and single lens.

Twin-Lens Reflex Camera. The twin-lens reflex design, introduced in 1920 as the Rolleiflex camera from Franke & Heidecke of Braunschweig, was the first popular reflex body style. It uses two matched lenses, one for focusing and one for imaging (Fig. 4-6). A fixed mirror acts to reflect a laterally reversed image onto a view screen, a design that minimizes parallax, except at short distances, because the two lenses are close enough together that the borders of the viewing image closely match borders of the film image. At short distances, however, parallax persists and can be completely corrected only at great expense, as in the Rolleiflex family of cameras.

There are several major advantages of the twin-lens reflex camera body. For one thing, the fixed mirror produces a viewing image the same size as the film image. And the viewing image is

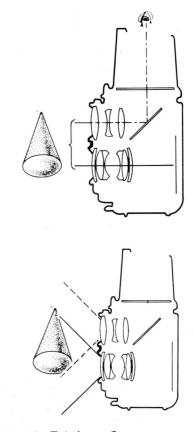

Figure 4-6 Twin-lens reflex camera. Parallax is minimized because the two lenses are offset only slightly in the vertical plane. However, a slight parallax still exists (solid line and dashed line).

visible even at the moment of exposure. The fixed mirror also allows for simple, rugged construction and quiet operation.

Single-Lens Reflex Camera. Efforts to completely eliminate the problem of parallax led to the invention of the single-lens reflex camera in Germany at the end of the nineteenth century. However, most improvements to the design came after World War II.

The single-lens reflex camera uses a mirror hinged at a 45-degree angle behind its single lens to reflect the image up to a view screen for focusing. At the moment of exposure, the mirror swings out of the way so the image light can expose the film (Fig. 4-7).

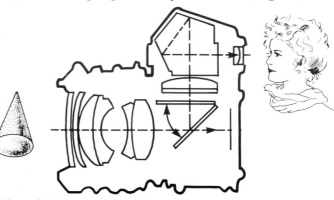

Figure 4-7 Single-lens reflex camera. The problem of parallax is eliminated because the single lens, with the aid of a retracting mirror, serves for both viewing and photographing the image.

Although the single-lens design eliminates parallax, it also introduces some other problems. The camera is larger and heavier than one without a mirror. And as the mirror swings out of the way for exposure, it makes a loud—possibly disruptive—noise, can cause the camera to move, and leaves the photographer "blind" at the moment of exposure. The camera is also difficult to focus under low light because the viewfinder image is dimmed by the extra distance the reflected light must travel inside the camera before it reaches the focusing screen. The camera's complex design usually adds to its price as well.

There are many advantages to the single-lens reflex design that counterbalance the drawbacks. As already mentioned, having a single lens for both viewing and taking the picture completely eliminates parallax. In addition, even with an accessory lens, both field of view and depth of field are discernible through the viewfinder. The camera can also be operated quite quickly, making it especially suited for candid photography.

Pinhole or Lens

In the light-tight box, only image-forming light can reach the film through the aperture, which can be either a pinhole or a lens of varied quality. An extremely basic camera has a pinhole that gathers light but does not focus it. The smaller the pinhole, the

Figure 4-8 Pinhole cameras and images.

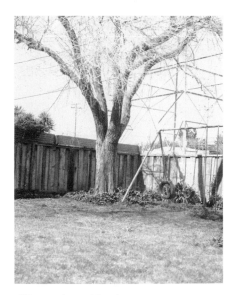

Photo taken with a lens.

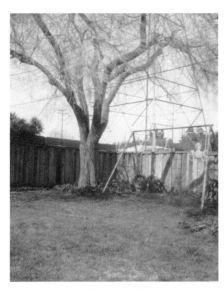

Photo taken with a pinhole

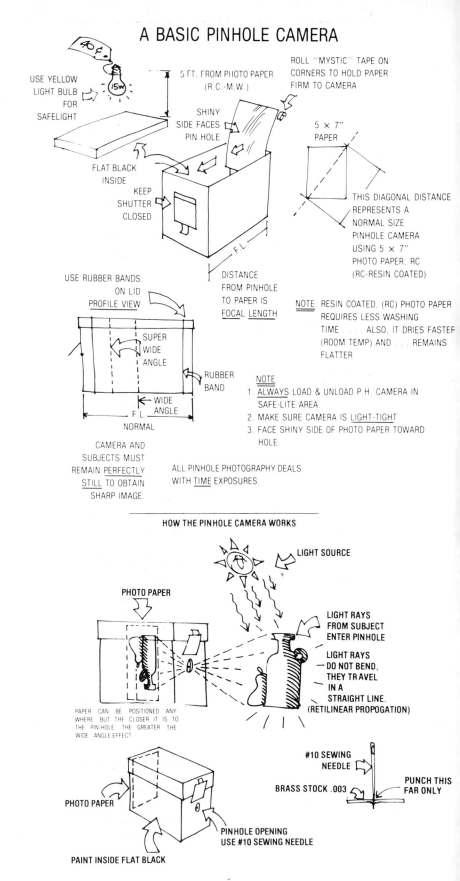

A BASIC PINHOLE CAMERA

USE YELLOW LIGHT BULB FOR SAFELIGHT

15w

5 FT. FROM PHOTO PAPER (R.C.-M.W.)

SHINY SIDE FACES PIN HOLE

ROLL "MYSTIC" TAPE ON CORNERS TO HOLD PAPER FIRM TO CAMERA

FLAT BLACK INSIDE

KEEP SHUTTER CLOSED

F.L.

5 × 7" PAPER

THIS DIAGONAL DISTANCE REPRESENTS A NORMAL SIZE PINHOLE CAMERA USING 5 × 7" PHOTO PAPER, RC (RC-RESIN COATED)

DISTANCE FROM PINHOLE TO PAPER IS FOCAL LENGTH

USE RUBBER BANDS ON LID PROFILE VIEW

SUPER WIDE ANGLE

RUBBER BAND

WIDE ANGLE

F.L.

NORMAL

CAMERA AND SUBJECTS MUST REMAIN PERFECTLY STILL TO OBTAIN SHARP IMAGE.

NOTE: RESIN COATED, (RC) PHOTO PAPER REQUIRES LESS WASHING TIME ALSO, IT DRIES FASTER (ROOM TEMP) AND REMAINS FLATTER

NOTE:
1. ALWAYS LOAD & UNLOAD P.H. CAMERA IN SAFE-LITE AREA.
2. MAKE SURE CAMERA IS LIGHT-TIGHT
3. FACE SHINY SIDE OF PHOTO PAPER TOWARD HOLE.

ALL PINHOLE PHOTOGRAPHY DEALS WITH TIME EXPOSURES.

HOW THE PINHOLE CAMERA WORKS

LIGHT SOURCE

PHOTO PAPER

LIGHT RAYS FROM SUBJECT ENTER PINHOLE

LIGHT RAYS DO NOT BEND, THEY TRAVEL IN A STRAIGHT LINE. (RETILINEAR PROPOGATION)

PAPER CAN BE POSITIONED ANY-WHERE BUT THE CLOSER IT IS TO THE PIN-HOLE THE GREATER THE WIDE ANGLE EFFECT

PHOTO PAPER

PINHOLE OPENING USE #10 SEWING NEEDLE

PAINT INSIDE FLAT BLACK

#10 SEWING NEEDLE

BRASS STOCK .003

PUNCH THIS FAR ONLY

Screw mount

Bayonet mount

Figure 4-9 Lens mounting systems. (Courtesy of Soligor AIC Photo, Inc.)

sharper but dimmer is the image. If the pinhole is enlarged, the image brightens but becomes less sharp.

The angle of coverage of a pinhole camera is determined by image distance; image size is dependent on subject distance. Although a pinhole image can never be as sharp as an image produced with a high-quality lens, everything in the image is of even sharpness. This is because the pinhole image has infinite depth of field. Pinhole cameras are easy to manufacture. They can also produce very interesting pictures, as shown in Figure 4-8.

Most modern cameras use lenses to focus light on the film. Image sharpness is then a function of lens quality. The simplest lens consists of one element, but the best-quality images are formed with a multilens system, as discussed in Chapter 2.

Lens Mount. Most precision cameras offer interchangeable lenses as an accessory (see Ch. 2). One important feature of interchangeable lens systems that is often overlooked when selecting a camera is the lens mount. The lens mount is almost as crucial to image sharpness as is the quality of the lens glass, because the lens mount holds the lens perpendicular to the film to ensure edge-to-edge sharpness and tight enough against the camera body so that extraneous light cannot enter the body and fog the film.

The simplest lens mount system is the screw mount, which provides perfect alignment and is highly efficient (Fig. 4-9). Unfortunately, changing lenses requires extra time; avoiding stripping the threads of both lens and camera mount takes great care.

To speed the changing of lenses, there is the bayonet mount, which is threadless. The lens mounts into place with a simple twist. The manufacture of high-quality bayonet mounts is, however, difficult and expensive (Fig. 4-9).

Film Holder

A sharp image requires that the film be perfectly flat across its entire surface. It is the film holder or pressure plate that holds the film securely in the focal plane. It must do this while allowing the film to advance without scratching the delicate emulsion. Some camera types, such as the 126 instant-load cartridge format, have no pressure plate. For this reason, enlargements from such negatives cannot be critically sharp.

Shutter

The shutter in its simplest form, as in the pinhole camera, is a cap or flap over the aperture, that is removed to expose the film for a predetermined amount of time. This type of shutter was common during the nineteenth century, when available film had low sensitivity to light and required exposures of seconds or minutes

duration. As more sensitive film became available, more sophisticated shutters were designed.

Leaf or Blade Shutter. The leaf or blade shutter, devised in 1903 by Deckel in Germany, is usually located between the lens elements and acts to expose the entire piece of film at once. (Fig. 4-10).

The blade shutter consists of thin blades pivoted at their outer edge and linked to a ring that rotates (driven by springs) so the blades open from and close back toward the center of the lens. This opening and closing action limits the speed of the blade shutter—usually to a maximum of 1/500 of a second, a definite disadvantage.

Another disadvantage of the blade shutter is its location, because changing lenses requires a new shutter for each new lens. Although front-lens-element interchangeability is available, the quality of optics is not usually as good as the optics in a fully interchangeable lens system.

There are advantages to the blade shutter: It is quiet, free of vibration, and easy to synchronize with flash systems (because an entire frame of film is exposed at one time).

Focal-Plane Shutter. The focal-plane shutter, developed by Anschutz in Germany in 1888, overcame the limit on maximum shutter speed associated with the blade shutter. The focal-plane shutter consists of two curtains of opaque material mounted on rollers and placed directly in front of the film, at the focal plane. A slit between the two curtains travels across the film to expose it, a section at a time. Slits of different widths in combination with different spring tensions result in a great variety of shutter speeds, up to 1/4000 of a second. The shutter's focal-plane placement makes it easy to change lenses without replacing the shutter (Fig. 4-11).

The focal-plane shutter can unfortunately distort the image of a rapidly moving subject, because different parts of the image are exposed at different times. With a horizontal shutter, such an image is lengthened or compressed, depending on whether the subject was traveling with or against the shutter direction. A vertical shutter inclines the image forward or backward, again depending on the direction of the shutter (Fig. 4-12).

Because the focal-plane shutter does not expose all portions of the film at the same time, flash synchronization is a problem, one that requires special, long-duration flash bulbs or a relatively slow shutter speed with electronic flash. The problems of synchronization of shutter and flash are discussed in Chapter 6.

Choosing a Camera

With the ever-increasing popularity of photography have come many different types and sizes of camera for both the amateur and

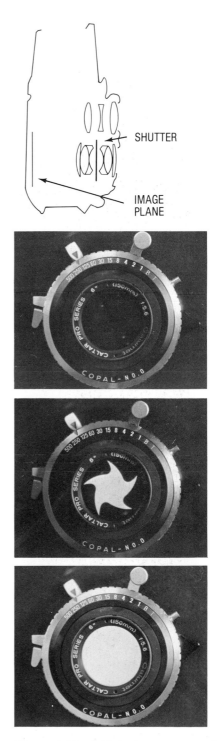

Figure 4-10 A blade shutter opens and closes from the center to expose an entire frame of film at one time.

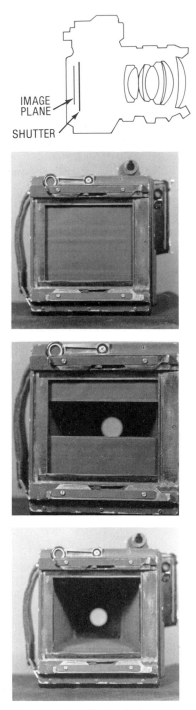

professional photographer. The continually increasing costs of photographic materials mean that one should not purchase a camera without a clear understanding of one's photographic needs and expense limits. As with any tool, no camera is suited to every application. With diligent research, you should be able to find a camera within your price range that meets most of your needs.

Nonadjustable Camera. Typical box cameras and inexpensive instant-load cartridge film cameras have a viewfinder, fixed focus, and fixed exposure (Fig. 4-13). Although such cameras can take acceptable pictures of subjects that are in bright light and at least six feet from the lens, the slow factory-fixed shutter speed (usually 1/60 of a second) makes it quite difficult to take action shots. This type of camera produces small negatives on 110 or 126 film, which limits the size of enlargements to 5 in. x 7 in. or 8 in. x 10 in.

Subminiature Camera. Most subminiature cameras use a viewfinder type body, although single-lens reflex models are now entering the market. The variety of subminiature cameras (with prices

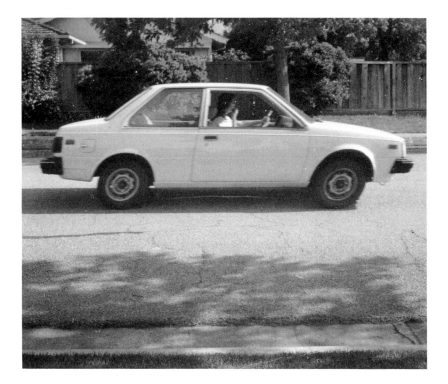

Figure 4-11 The focal-plane shutter does not expose an entire frame of film at once. Instead, it exposes only the portion behind the moving slit as the slit travels across the film.

Figure 4-12 The focal-plane shutter can distort the image of a moving subject because as the shutter moves across the film, different parts of the image are exposed at different times. Since the focal plane shutter that exposed this picture traveled vertically, both the body and the tire shapes of the car were distorted.

ranging from $25 for nonadjustable models to over $300) is quite impressive. All, however, suffer from the same fault: Small film size (16mm) necessitates unusual care in exposing and processing the negative or transparency. As with nonadjustable cameras, small film size limits the enlargement to a maximum of 8 in. x 10 in.

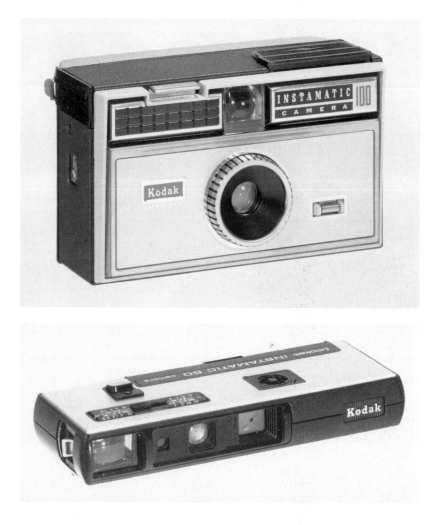

Figure 4-13 The instant-load cartridge film camera opened the world of photography to many people who were intimidated by more complicated cameras. (Courtesy of Eastman Kodak Co.)

a. The first type of instant-load camera took a 126 cartridge close in size to 35-mm film.

b. The 110 instant-load camera is more compact because it takes a smaller (9 mm) film size.

The latest style subminiature is the disc camera, first introduced by Eastman Kodak Co., which uses a novel disc-film format with 15 exposures (of 8mm x 10mm) per disc. The disc design makes it especially easy to load film. The camera features automatic coupling of film sensitivity to a built-in light meter, a glass F/2.8 lens, a motor drive for film advance, and an automatic electronic flash that only fires when needed. Because the film remains in the disc during processing and printing, disc film gives greater protection to processed negatives than any other camera film type. Another

major advantage of the disc format is a magnetic data strip on the disc itself, which at the time of processing is encoded with developing and printing data to ensure consistent quality of reprints and also helps keep track of the disc during its stay in the lab (Fig. 4-14).

Figure 4-14 Disc camera. (Courtesy of Eastman Kodak Co.)

a. Eastman Kodak disc cameras with sample prints.

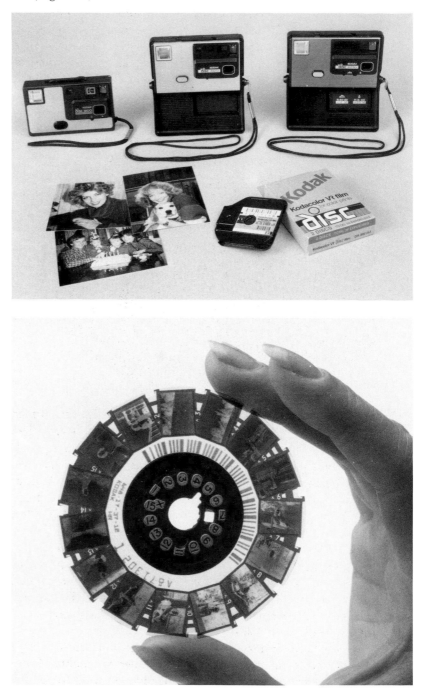

b. A disc of processed film showing the 15 separate negatives that remain permanently in the disc.

Miniature Camera. The miniature camera, which uses double-frame 35-mm motion picture film and which is available in both viewfinder and single-lens-reflex styles (priced from $50 to $1000+), has become the most popular of all advanced cameras, especially for color prints and transparencies.

The camera's compact size allows for a long film roll, wide-aperture lenses, interchangeable lenses, and a myriad of advanced accessories. Improvements in film sensitivity and sharpness have made relatively sizable enlargements feasible, and most kinds of film emulsion are available in this popular size. The camera, compact enough to hold in the hand, is highly portable (Fig. 4-15)

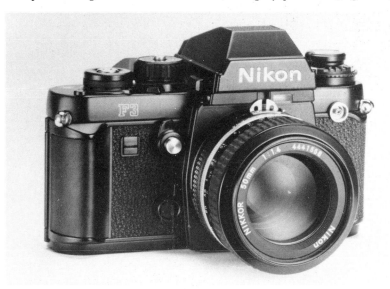

Figure 4-15 Miniature camera (Nikon F3). (Courtesy of Nikon, Inc.)

Medium-Format Camera. The medium-format camera, which comes in both twin-lens-reflex and single-lens-reflex styles at prices from $500 to $2000+, is generally used by the professional photographer or advanced amateur. Medium-format camera negatives, being larger than miniature camera negatives (2-¼ in. x 2-¼ in. or 2-¼ in. x 2-¾ in.), can produce higher-quality and larger-size (to 20 in. x 24 in.) enlargements or reprints from transparencies (Fig. 4-16).

Large-Format Camera. The large-format camera is big enough to need a suitable tripod or other support and is most often employed by the professional photographer (Fig. 4-17). The limited number currently being produced makes these cameras quite expensive—from $500 to well over $3000.

Because the large-format camera uses large-dimension film, it produces negatives or transparencies of superior quality. Some models, called view cameras, have perspective controls for photo-

graphing architectural subjects. When the view camera's back is adjusted parallel to the subject plane by means of tilts or swings, convergence of perspective lines is eliminated (Fig. 4-18).

Figure 4-16 Medium-format camera.

a. Mamiya twin-lens reflex cameras with interchangeable lenses. (Courtesy of Osawa & Co.)

b. Rolleiflex SL66E camera with electronic through-the-lens metering of both daylight and flash scenes. (Courtesy of Rollei fototechnic)

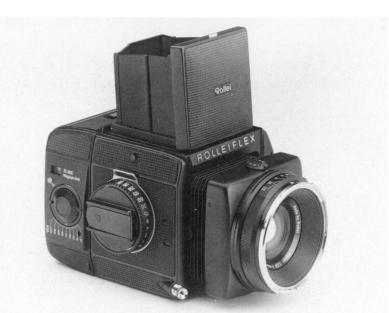

Figure 4-17 Large-format camera. A 4 in. x 5 in. view camera. (Courtesy of Tommy Gibson)

Uncorrected

Corrected

Figure 4-18 Perspective control. Tilts and swings found on view cameras can prevent convergence of vertical and horizontal lines. A corrected photograph will not give the impression of a subject that appears to be falling over as displayed in the uncorrected print.

Special Cameras

Not all cameras fit into the standard categories presented thus far, because of different size film, different format, or specialized processes.

Three-Dimension Camera. The three-dimension camera is a miniature camera that produces three-dimensional images, typically as color transparencies for slide projection. Some of the drawbacks of 3-D photography have been the needs for special mounting of the transparencies, for a special projection screen, and for special viewing glasses to blend multiple images into one three-dimensional image. Recently there has come available a 35mm 3-D camera with automatic exposure control (manufactured by Nimslo), which for the first time makes three-dimensional prints possible. Currently the camera uses standard 35mm color negative film, which must be returned to the manufacturer of the camera for special printing (Fig. 4-19).

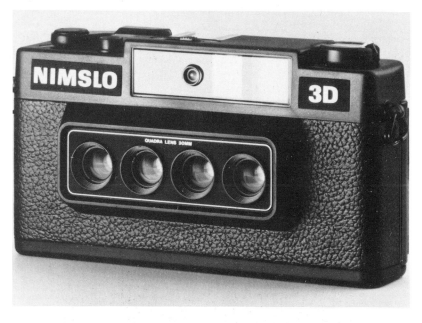

Figure 4-19 Nimslo 35-mm 3-dimension camera has four 30-mm F/5.6 lenses precisely mounted to provide the separation necessary to produce sharp, 3-dimensional images. This is the first camera designed to produce 3-dimension color prints. (Courtesy of Nimslo Corporation)

Instant-Print Camera. Instant-print photography started in 1948 with the introduction of Edwin Land's model 95 Polaroid camera and type 40 film, which produced a sepia-colored print one minute after exposure. The sepia film was replaced in 1949 with a black and white print material of higher sensitivity. Polaroid color roll film, Polacolor, was first introduced in May of 1963. The new SX70 integrated pod system was introduced to the annual meeting of the Society of Photographic Scientists and Engineers in San Francisco in 1972 and brought new film types and cameras to the

market (Fig. 4-20). Polaroid introduced a new line of 35mm
transparency films during the 1982 Photokina in Cologne, Germany,
including two types of continuous-tone film, one in black and white
and one in color, and a high-contrast black and white film for title
slides. All these films are exposed in normal 35mm cameras and
instantly processed in the field using special equipment available
from Polaroid. Polaroid introduced an entirely new camera and film
system in mid 1986. The Spectra system of cameras and film uses
new technology to produce pictures of much higher quality than
previous models (Fig. 4-21). The Spectra camera has a sonar auto-
rangefinder, automatic exposure control, and built-in electronic
flash with 1/5 second flash recharge for both full flash and flash
fill. All these automatic controls may be overriden and set
manually. The film produces images in a rectangular format, and
the color image is produced using new dyes and processing
technology.

Polaroid currently produces automatic as well as manual and
specialized cameras and offers the user both black and white and
color films.

Eastman Kodak Co. introduced its instant process and cameras
on April 10, 1976. This system remained in production with
refinements until 1986, when litigation with the Polaroid Corpora-
tion required its removal from the market.

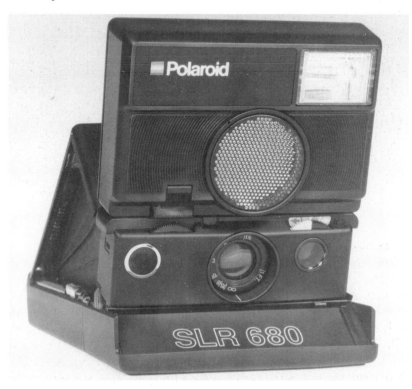

Figure 4-20 Polaroid SLR 680 auto-focus/auto-strobe folding camera uses the new Polaroid 600 ISO film, which make possible faster shutter speeds with increased depth of field. (Courtesy of Polaroid Corporation)

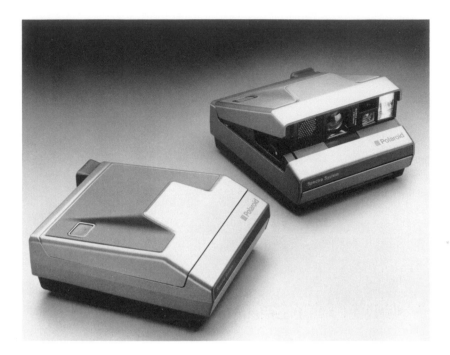

Figure 4-21 Polaroid Spectra camera
system. The "X Ray" view displays the
many electronic systems included in this
camera design. (Courtesy of Polaroid
Corporation)

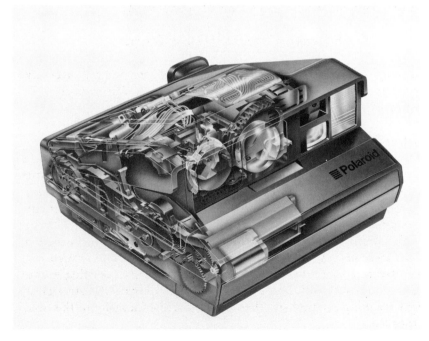

Chapter 5

Photographic Exposure

Radiant light energy as it passes through a pinhole or is refracted through a camera lens will produce a latent image on light-sensitive film (that is, it will expose the film). Photographic exposure has two key characteristics, intensity and time (duration), which are related mathematically by the **Law of Reciprocity:**

$$\text{Exposure} = \text{Intensity x Time (Duration)}$$

Although this equation is accurate enough for normal, daylight photography, it may be somewhat inaccurate for exposures in extremely low or high levels of light.

Intensity

Lens Aperture. The intensity of radiation that reaches a camera's film depends largely on the diameter of the lens aperture: The larger the opening, the more light is passed. In lenses that lack an aperture, light intensity can be controlled with neutral density filters (see Ch. 7).

The first type of **variable camera aperture** was called a *waterhouse stop.* A metal plate with a round hole drilled through was inserted into a slot between the lens elements. By inserting waterhouse stops with different size holes, one could vary the amount of light reaching the film and thereby control the intensity of the final exposure.

The modern camera uses a variable size **iris diaphragm** to control the amount of light reaching the film. The circular aperture created by the iris's series of overlapping metal blades is enlarged or diminished by rotating a ring on the lens barrel (Fig. 5-1).

Figure 5-1 An iris diaphragm as found in the modern camera.

F/ Stops. In addition to aperture size, image intensity or brightness is also a function of lens focal length. Thus, both focal length and aperture size must be taken into account when figuring the maximum intensity of exposure through a particular lens. This maximum aperture can be determined with the **relative aperture formula:**

$$F/_r = \frac{\text{Lens focal length}}{\text{Lens front-element diameter}}$$

in which F/r is the symbol for relative aperture. This formula will determine the lens's "speed" or maximum aperture. Thus, for a lens, whose diameter is one-fourth its focal length (x), the F/stop of this lens when wide open is

$$F/_r = \frac{x}{x/4} = 4$$

and we call this an F/4 lens.

When a lens aperture is closed down to admit through less than the maximum amount of light for that lens, lens front-element diameter in the relative aperture formula becomes lens aperture

diameter. The formula in this case becomes

$$F/ = \frac{\text{Lens focal length}}{\text{Aperture diameter}}$$

This aperture formula shows us that as the F/stop number is increased, the brightness of the image decreases. It is also true that

$$\text{Image brightness} = \left(\frac{\text{Lens diameter}}{\text{Lens focal length}}\right)^2 = \frac{1}{(F/)^2}$$

That is, image brightness varies as the inverse of the square of the F/number. Thus, to double the brightness of an image, we must decrease the F/stop number by $\sqrt{2}$ (approximated as 1.4). In general, we can determine the F/stop that adjoins another F/stop (that will double or halve the intensity of its neighbor) by multiplying (or dividing) the known F/stop by 1.4 (Fig. 5-2).

The following sequence of F/stops has been made standard for all camera lenses: F/1.0, F/1.4, F/2.0, F/2.8, F/4, F/5.6, F/8, F/11, F/16, F/22, F/32. By international agreement, every camera must use part or all of this series and may add F/stops beyond either extreme as long as they are arithmetically associated to their neighbor by a factor of 1.4 (Fig. 5-2). Some lenses have as their relative aperture a non standard F/stop, and lenses with a relative aperture of F/1.8, F/3.5, or F/4.7 are quite common. However, regardless of the relative aperture of the lens, its remaining F/stops must conform to the standard.

Figure 5-2 F/stop settings as found on a camera lens.

Because an iris diaphragm is continuously variable, the F/stop ring can be set in between stated values. If a proper exposure requires F/6.3, for instance, the aperture can be set between F/5.6 and F/8.

Time (Duration)

The second variable in the Law of Reciprocity is **time** or **duration,** that is, the amount of time that exposing light is allowed to strike the film. In the modern camera, a shutter placed in the path of the exposing radiation controls the duration of exposure. By varying how long the shutter remains open, we can control the amount of light energy that reaches the film. Shorter durations allow less exposure, and longer durations give greater exposure.

Shutter Speed. The same international agreement that standardized F/stops also established standard shutter speeds. F/stops are correlated with shutter speed so that each adjoining shutter speed is either double or half the duration of its neighbor. A typical sequence of shutter speeds starts with a full second's duration and continues as follows: 1/2 second, 1/4, 1/8, 1/15, 1/30, 1/60, 1/125, 1/250, 1/500, and 1/1000. Shutter speeds may extend beyond either extreme as long as the additional speeds are either double or half the neighboring shutter speed (Fig. 5-3).

Figure 5-3 Shutter speed settings as found on a camera.

Because shutter speeds as marked on a camera usually show the *inverse* of duration (the denominator of the fractional part of a second, for instance, "2" for 1/2 second or "4" for 1/4 second), the user must remember that the larger the whole-number shutter speed, the shorter the exposure duration.

Slow Shutter Speeds. Some camera shutters have additional settings, marked either B or T. These extra settings produce the slowest shutter speeds. Set on B, a shutter will remain open as long as the release is depressed. With the T setting—normally for *very* long exposures—the shutter opens when the release is depressed and remains open until the shutter release is depressed again. Either of these settings necessitates great care lest the camera move and blur the photograph (Fig. 5-4).

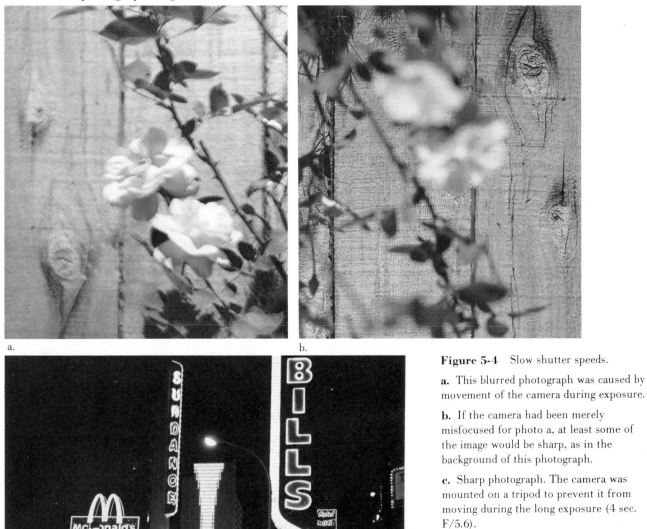

a.

b.

c.

Figure 5-4 Slow shutter speeds.

a. This blurred photograph was caused by movement of the camera during exposure.

b. If the camera had been merely misfocused for photo a, at least some of the image would be sharp, as in the background of this photograph.

c. Sharp photograph. The camera was mounted on a tripod to prevent it from moving during the long exposure (4 sec. F/5.6).

Unlike aperture controls, there is no way in most cameras to set shutter speeds intermediate to those marked without serious damage to the shutter. Certain modern electronic shutters, however, are an exception to this rule.

Equivalent Exposures

Because exposure is doubled each time F/stop or shutter speed is decreased one setting, equivalent or equal exposures are produced whenever shutter speed is doubled while the aperture is halved or closed down one full stop. For example, film exposure will be the same for 1/60 second at F/16 and 1/30 second at F/22 (Fig. 5-5).

We can determine the number of F/stops by which to change exposure by remembering that exposure is doubled for each full setting's decrease in F/stop number. Thus, in our example, to increase exposure 4X we would need to open up two full F/stops.

Determining Correct Exposure for Daylight Scenes

To determine the correct exposure for a given daylight scene, we must consider three variables: (1) the film's sensitivity to light (film speed), (2) the lighting around the subject, and (3) the brightness of the subject.

Film Sensitivity or Speed. Photographic film's sensitivity to light is indicated by the film's American National Standards Institute and ISO film speed rating, which is established through the scientific testing of photographic materials under conditions that closely duplicate those of normal picture taking. Film speed is always one of the following series of numbers which are related to each other by the cube root of 2: 10, 12, 16, 20, 25, 32, 40, 50, 64, 80, 100, 125, 160, 200, 250, 320, 400, 500, 650, 800. This series of film speeds continues on by multiplying the last number by the cube root of 2 or 1.26. In this way, each adjoining number is equivalent to 1/3 of an F/stop increase or decrease in sensitivity. The higher the film speed number, the greater the film's sensitivity to light, in arithmetic progression. Thus, ISO 100 film is twice as sensitive as ISO 50 film and four times as sensitive as ISO 25 film.

Subject Lighting. There are four basic categories of subject lighting in natural-light photography, and they are easily gauged from the type of shadows cast by objects in the subject area:

1. **Bright sun**—this produces clearly defined, dark shadows.

2. **Hazy sun**—sun is obscured by heavy haze, creating indistinct, gray shadows; requires twice the exposure of bright sun.

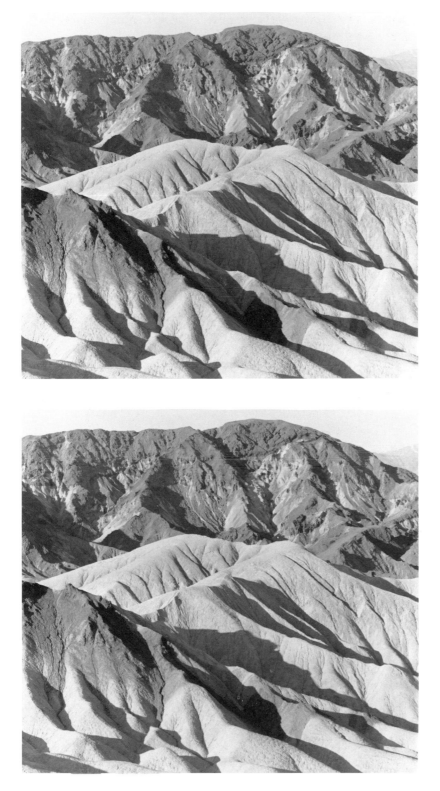

Figure 5-5 The effective exposures for these two photographs are equivalent.

1/60 sec. at F/16

1/30 sec. at F/22

3. **Cloudy-bright**—sky is totally overcast, creating no shadows; requires four times the exposure of bright sun.

4. **Open shade**—subject is in the shade, although bright open sky is the main source of illumination; requires four to eight times the exposure of bright sun depending on the reflectivity of objects surrounding the subject.

Subject Brightness. The brightness of a subject can also affect exposure. If a subject is of normal brightness, no change in exposure is required. However, an extremely bright or extremely dark subject will require closing down or opening up of the aperture by ½ an F/stop to correct for the abnormal brightness.

1/ISO Method. Proper photographic exposure for outdoors may be approximated by equating shutter speed with the inverse of ISO film speed and selecting an F/stop appropriate to the subject lighting. Table 5-1 displays this relationship. From the table we can see, for example, that proper exposure for ISO 125 film on a sunny day would be 1/125 second at F/16. For stop-action capability, the photographer could select an equivalent exposure with a faster shutter speed. To alter depth of field, the photographer might choose an equivalent exposure with a different F/stop. Table 5-2 lists some equivalent exposures for this example.

Table 5-1
OUTDOOR EXPOSURE, 1/ISO METHOD

LIGHTING	CORRECT EXPOSURE
Bright sun—Shadows are dark and clearly defined.	Base exposure = 1/ISO at F/16
Hazy sun—Sun is obscured by heavy haze; shadows are gray and indistinct.	Base exposure x 2 = 1/ISO at F/11
Cloudy bright—Sky is overcast; there are no shadows.	Base exposure x 4 = 1/ISO at F/8
Open shade—Subject is in shade from bright skylight.	Base exposure x 4 to 8 = 1/ISO at F/8 to F/5.6

Table 5-2
EXPOSURES EQUIVALENT TO 1/125 AT F/16

SHUTTER SPEED	1000	500	250	125	60
F/ STOP	5.6	8	11	16	22

Exposure Change, Image Magnification, and Bellows Factor. As an image grows larger, exposure must be increased because the image formed is farther from the lens and spread over a larger area. To determine the needed increase in exposure, we use a **bellows factor**, easy to do when image magnification (M) is known. The photographer usually takes the bellows factor into consideration *only* when magnification is equal to or greater than 1; however, when a subject is less than 10 focal lengths from the lens, the image produced will be underexposed and in need of correction.

Once magnification is known, the factor by which exposure must be increased can be determined with the following equation:

$$\text{Bellows factor} = (M + 1)^2$$

For example, an image with magnification of 1 needs an increase in exposure of $(1 + 1)^2 = 4X$. Without this increase, serious underexposure would result.

The geometric method for determining magnification (discussed in Ch. 3) can be used to find the bellows factor, because bellows factor also equals the square of the number of focal lengths in the image distance:

$$\text{Bellows factor} = \left(\frac{\text{Image distance}}{\text{Focal length}}\right)^2$$

With a natural-size image, image distance is exactly 2 focal lengths, so the necessary increase in exposure is $(2/1)^2$, or 4X (Fig. 5-6).

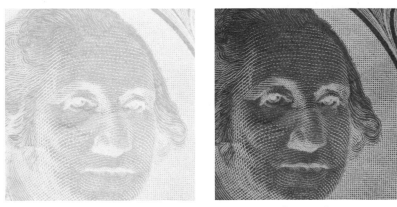

Uncorrected Corrected

Figure 5-6 If bellows factors are ignored during macography, serious underexposure will result.

Light Meters

We employ a light meter to accurately measure how much light falls on or is reflected from a subject or scene.

Exposure Slide Rules. The simplest type of light meter is a slide rule device, either straight or rotary, that shows shutter speeds (equated with the inverse of the ISO rating) and F/stops. Such exposure slide rules are easy to make. See the boxed section for details on how to make and use a straight exposure slide rule. To make a rotary slide rule, use the dial that appears at the end of this book.

HOW TO MAKE AND USE A
STRAIGHT EXPOSURE SLIDE RULE

1. Draw a line across a sheet of vertically lined paper or graph paper.
2. At equal intervals along the line, write shutter speeds above the line and F/stops below the line.
3. Cut along the line so you have two strips, one with shutter speeds and one with F/stops.
4. Use the inverse of the ISO rating as base shutter speed and select an F/stop appropriate to the subject lighting.
5. Align the chosen F/stop under the base shutter speed and all equivalent exposures are now aligned.

Shutter Speed	1000	500	250	125	60	30	15	8	4	2	1
F/stop	2	2.8	4	5.6	8	11	16	22			

Cut along line

Example of a straight exposure scale.

Photoelectric Meters. Photoelectric meters can accurately measure the amount of light reflected from or falling on a scene if used properly (Fig. 5-7). The most popular light meter used to be the selenium-oxide type until the introduction of the battery-boosted cadmium sulfide (CdS) cell, which reads better under low light. Unfortunately, *very* low levels of illumination can cause the CdS meter to "creep" or register slowly. The CdS cell also exhibits a problem called *memory:* When there is a sudden and vast change in illumination, the meter remembers the previous reading and takes time to correctly register the new exposure.

Two new types of photoelectric cells have recently been introduced. They exhibit no memory and respond very quickly, with battery assistance, to low levels of illumination—the silicon blue (Sbc) cell and the gallium-arsenic phosphide (GAP) cell.

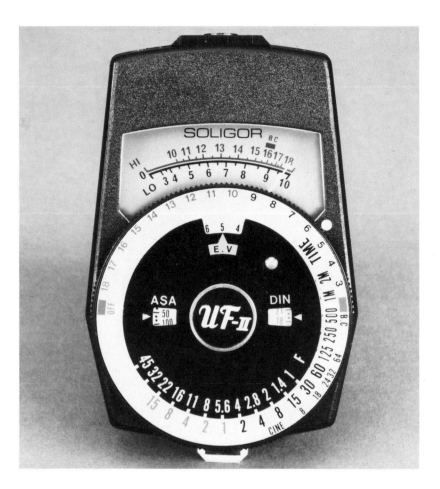

Figure 5-7 Battery-boosted light meter. (Courtesy of Soligor AIC Photo, Inc.)

Incident Light vs. Reflected Light. Photoelectric meters come in two varieties, the incident-light meter and the reflected-light meter. The **incident-light meter** is used to measure all the light actually falling directly on the subject—from the sun, the sky, or any lamps. Because the incident-light meter does not take into account light reflected from the subject or from objects surrounding the subject, it can lead to incorrect exposure when reflected light is widely different from incident light. Incident meters are especially suited to the studio or other settings where lighting is controlled so that all objects provide normal reflectance.

The most commonly used meter is the **reflected-light meter** because it takes into account the reflectance of the subject and all surrounding objects, even if abnormally lit. A special variety of reflected-light meter is the **spot meter**, which reads a narrow angle of light (usually 1° to 3°), thus enabling the photographer to take specialized, small-area readings (Fig. 5-8).

All built-in meters in cameras are reflection types. They may average the entire field of view to obtain the proper reading, or

they may narrow the meter's field of view by weighing the reading at the center or the bottom of the image area. Some meters allow the photographer to change the weighing pattern to fit special exposure needs.

The built in meter may operate as a manual hand-held meter, or it may be coupled to the camera operation. A coupled metering system may be either semiautomatic or fully automatic. The semi-automatic systems will set either the aperture or the shutter speed while the photographer selects the remaining component of exposure.

Just as with hand-held meters, the built-in meter must be set with the proper ISO film speed in order to determine correct exposures. A new addition to 35-mm film and magazines is machine-readable data strips called DX codes. Two code sets on the magazine will set the proper ISO in the camera's built-in meter, tell the counter how many frames of film in the roll, and allow the photo finisher to more easily sort film types to the proper processing machine. The two codes on the film are both for use by the photo finisher. As more cameras are able to read the ISO portion of the DX code, exposure errors due to improper film speed setting will be eliminated.

Regardless of the kind of light meter you use or the type of cell in the meter, it is wise to check the meter's accuracy at every shooting session by comparing its determination with that obtained by the 1/ISO method.

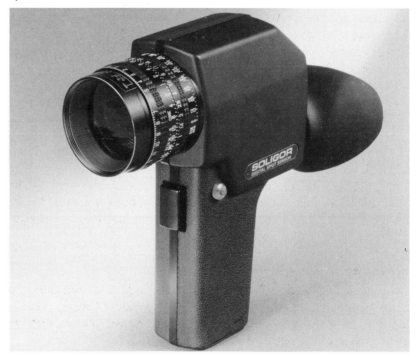

Figure 5-8 Digital spot meter.
(Courtesy of Soligor AIC Photo, Inc.)

Chapter 6

Artificial Light

In Chapter 1, we learned the properties of radiant energy. In this chapter, we will further our knowledge of radiant energy by studying a special case, artificial light.

Production of Artificial Light

Artificial light, which is any light not produced by the sun and which as such must be handled specially by the photographer, can be produced in two different ways, chemically and physically. In the **chemical production** of artificial light, the substance used to produce the light is chemically altered and becomes an entirely different substance. For example, as a match or candle burns, it changes from paper, wood, or wax into light and gasses.

The **physical production** of artificial light, on the other hand, does not alter the basic material. For example, place a piece of iron in a fire, and it will glow and emit light but will remain iron. Even when it cools and no longer emits light, it is still iron. The substance producing the light has not changed chemically. The ordinary house light bulb produces light by physical means, for its tungsten filament glows to emit light and heat but does not change chemical identity as it cools.

Continuous and Discontinuous Light

Regardless of how artificial light is produced, it is important to know whether the light is spectrally **continuous**—that is, consisting of all visible wavelengths—or **discontinuous**, that is, missing some visible wavelengths in its output (Fig. 6-1).

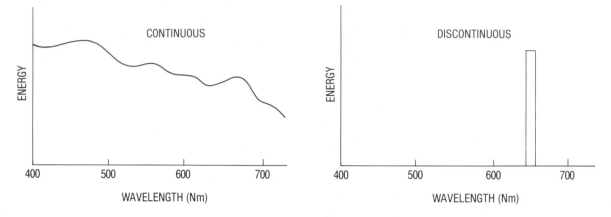

Figure 6-1 Continuous and discontinuous light sources. A continuous source of light radiation consists of all visible wavelengths. A discontinuous source (such as a sodium vapor lamp) is missing some visible wavelengths in its output.

Continuity of light is important for both black and white and color photography. Because all film, whether black and white or color, is more sensitive at the blue (short wavelength) end of the spectrum (see Ch. 1), film exposed only to red light (longer wavelength) from a discontinuous source will be quite under-exposed. In addition color film will show a color shift toward the dominant hue. Exposed only to red light, for instance, color film will produce a print or slide that is red only. No filter can correct such a color shift, for filters can pass only their own additive primary colors, (Red, Green, Blue), if present in the scene or incident light and cannot add their color(s) if absent from the scene or light source (Fig. 6-2). (See Ch. 7 for a complete discussion of filters.)

Kelvin Scale. We can rate continuous light on a color comparison temperature scale called the **Kelvin scale**. The bluer the light source, the higher the Kelvin temperature. The redder the light source, the lower the Kelvin temperature.

Flashbulbs

Flashbulb technology is an outgrowth of early photography's use of magnesium powder to artificially light indoor scenes. Unfortunately, magnesium powder would at the least leave behind messy ash, and at worst, start a fire. As film sensitivity increased, more controlled methods of producing artificial light were employed, and the flash lamp was developed.

The flashbulb, which comes in many different sizes and powers (Fig. 6-3), has filament wire made of magnesium, aluminum, or zirconium and produces a controlled, reliable light. Part of the filament is coated with a primer chemical, and the bulb, filled with

Continuous (daylight) Discontinuous (sodium vapor)

Figure 6-2 In a color photograph taken with a discontinuous source such as a sodium vapor lamp, colors such as green and red that are missing or of minimal output in the source will not record on the film, and the entire photo will be colored the dominant hue of the source. Note also the color shift in the grass background in the two photographs.

Figure 6-3 Examples of various sizes of flashbulbs, from the large screw-based bulb to the small flashcube. (Courtesy of Robert Buck)

Figure 6-4 Output of M-delay flashbulb. Notice that there is a 20-millisecond delay to full output, after which the output gradually decays to zero.

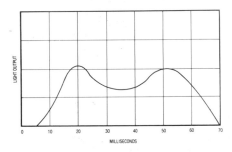

Figure 6-5 Output of FP flashbulb. Notice that there are two distinct peaks of energy output. Because the first peak occurs at 20 milliseconds, the FP flashbulb is considered to have an M-delay. The second peak ensures even output throughout the duration of travel of a focal-plane shutter.

oxygen, is then coated with a clear or blue safety plastic. A clear bulb has a spectral output of 3800°K and is designed to be used with any black and white film and with type F color film. The blue coating placed on some bulbs raises the Kelvin temperature to that of daylight (5800°K), so the bulbs can serve for daylight film.

M-Delay Bulb and FP Bulb. Most flashbulbs have a time lag between firing and maximum output, usually 20 milliseconds. The **M-delay bulb** (Fig. 6-4) reaches peak intensity 20 milliseconds after it is fired, and then gradually decays to zero output. The **FP bulb** also has a 20-millisecond delay but holds this peak for 20 to 25 milliseconds before starting to decay. This makes the FP bulb of value for focal-plane shutters, which need a definite interval of equal light output while the entire frame of film is being exposed (Fig. 6-5).

Once extremely popular, the flashbulb is rarely used now; electronic flash systems are more widely used.

Electronic Flash

Although a flashbulb is usable for one exposure only, the electronic flash can be fired many times (Fig 6-6). The electronic flash employs a tube filled with xenon gas that, when ionized, flashes with approximately the same spectral output as daylight. Because the gas ionizes instantly, the electronic flash has no delay. After its short, intense light, it dies as instantly as it started.

In order to recharge, electronic flash units require a recycle time between flashes—from a fraction of a second up to 20 seconds depending on the unit. During recycle time, current is drawn from either an AC circuit or built-in batteries (rechargeable or non-rechargeable).

Stop-Action. The first use of a high-speed electric spark as a photographic light source was recognized in a patent granted to William Henry Fox Talbot in 1851. Using a new test emulsion, Fox Talbot recorded the image of a newspaper spinning in a darkened room. Because exposure was initiated by an electric spark of short duration, the spinning newspaper appeared to be "stopped" in the photograph even though the actual shutter speed was quite slow.

Fox Talbot's early experiments displayed one of the major advantages of electronic flash: extremely short duration and a photograph that appears to be exposed at a very fast shutter speed. Although the duration of the typical electronic flash is around 1/1000 of a second, there are special units with a duration of 1/50,000 of a second that are capable of stopping even the fastest action (Fig. 6-7).

Flash Synchronization

Early artificial-light photography required no synchronization between the camera shutter and flash. The flash was fired after the shutter was opened; once the light died down, the shutter was closed. Thus, the entire output of the flash was utilized. As higher-sensitivity film was developed, the need to synchronize the flash with the camera shutter became apparent.

M-Synch and X-Synch. In order to be effective, a shutter must be open during the peak output of the flash. To achieve this synchronization of shutter and flash, a delay mechanism is built into the shutter. With **M-synch**, there is a 20-millisecond delay after the shutter release is depressed before the shutter actually opens. With **X-synch**, there is no delay before the shutter opens.

Blade Shutter vs Focal-Plane Shutter. Synchronization varies with the type of shutter as well as the type of flash. Blade shutters synchronize with flashbulbs or electronic flashes at any shutter speed. Focal-plane shutters synchronize with flashbulbs at any

Figure 6-6 A shoe-mounted electronic flash. (Courtesy of Vivitar Corporation)

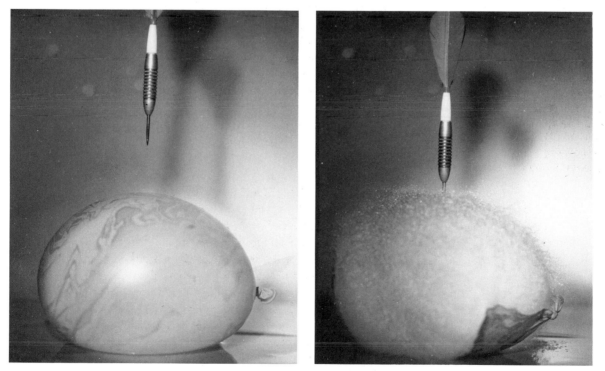

Figure 6-7 Action-stopping capability of electronic flash. A water-filled balloon was pierced by a dart and photographed with a specially designed electronic flash with a duration of one-millionth of a second (1 microsecond) to produce this interesting result. The balloon has collapsed while the water still holds the shape of its missing container. (Courtesy of Lockheed Missiles & Space Co.)

shutter speed and only at certain shutter speeds with electronic flashes. Table 6-1 recommends shutter speed, flash type, and synchronization for blade and focal-plane shutters.

Table 6-1 shows that FP(M)-synch works with flashbulbs at any shutter speed with focal-plane shutters but M-synch works only at faster shutter speeds with blade shutters. X-synch is used with flashbulbs with slow shutter speeds only with blade shutters. In this use, X-synch utilizes the entire output of the flashbulb—warm-up, full power, and die-down—making it especially useful for the slow shutter speeds needed for low lighting. Table 6-1 further shows that X-synch is used with blade shutters and electronic flashes at any shutter speed and is also used with focal plane shutters and electronic flashes, but only at the camera manufacturer's recommended shutter speeds.

TABLE 6-1
FLASH SYNCHRONIZATION

Shutter Type	Shutter Speed	Synchronization	Flash Type
Blade	1/60 and faster	M	Bulb
	1/30 and slower	X	Bulb
	Any speed	X	Electronic
Focal-plane	Any speed	FP (M)*	FP Bulbs
	Factory-recommended setting	X	Electronic

*FP is the same delay as M (20 milliseconds). The designation is found on cameras with Focal-Plane shutters.

As discussed in Chapter 4, the focal-plane shutter exposes film by moving a slit across the film plane, which takes longer than the marked shutter speed. Because the electronic flash unit has no warm-up or die-down, the flash of light could possibly shut off as the shutter slit travels across the film, resulting in a partially exposed frame of film (Fig. 6-8a). Employing the factory-recommended shutter speed (usually relatively slow) ensures that the lead curtain of the focal-plane shutter will be fully open before the end curtain cuts off the light, thereby exposing an entire frame

at once, with even exposure from edge to edge (Fig. 6-8b).

Whatever type of shutter or flash is used, proper synchronization is essential for proper exposure.

Figure 6-8 Synchronization of electronic flash with a focal-plane shutter.

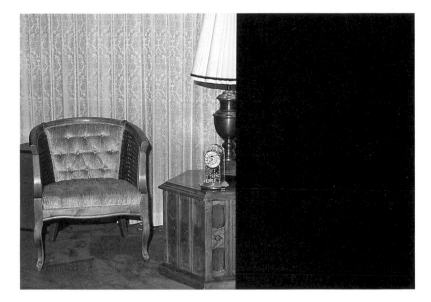

a. Faster-than-factory-recommended shutter speed used with a focal-plane shutter and electronic flash yields a partially exposed frame.

b. Factory-recommended shutter speed with the same camera and flash results in a full-frame picture.

Determining Correct Exposure for Flash

There are two different ways to determine the correct exposure for flash: manual and automatic. Both are based on the inverse-square law.

Manual Determination. The manual technique for determining exposure is made simple by a series of **guide numbers** (published by the manufacturers of film, flashbulbs, and electronic flash units) that are based on balancing bulb output with reflector size. You select the guide number appropriate to your shutter speed and film sensitivity. Dividing the guide number by the flash-to-subject distance gives the correct F/stop. An example of guide number tables and their use is displayed in Figure 6-9.

Guide Numbers for Adjustable Cameras

Below film speed and across from shutter speed, read guide number

FILM SPEED (see film inst. sheet)	10 to 12	16 to 20	25 to 32	40 to 64	80 to 125	160 to 200	320 to 500
Shutter Speed	Guide Number						
"X" or "M" Sync. Up to 1/30	65	80	100	150	190	260	380
1/60	60	75	95	130	180	240	360
"M" Sync. Only 1/125	50	65	85	120	150	200	300
1/250	40	50	65	90	120	160	240
1/500	30	40	50	70	90	120	180

For f-stop, divide Guide No. by distance in feet, lamp-to-subject. (Example: If Guide No. is 80, distance 10 ft., lens setting 80÷10 is f/8.) Guide for 4"-5" polished reflector; open ½ f-stop for others.

Flash with dry cell batteries, 3 volts or more. Check batteries frequently.

CONSUMER GUARANTEE: If, at any time, a Sylvania Flashbulb fails to flash, return it to:
Sylvania Electric Products, Inc.
Montoursville, Pennsylvania 17754
for 4 free prepaid replacement Flashbulbs. Offer good only in the U.S.A.

Figure 6-9 On the left is a guide number chart from the side of a flashbulb box. (Courtesy of Robert Buck) On the right is an exposure determination scale from the side of an inexpensive electronic flash.

Abnormal Conditions. Because guide numbers are meant to be applied to normal conditions, they can lead to incorrect exposure if the subject scene is in any way abnormal. Normal conditions mean a room 6 ft x 6 ft minimum to a 20 ft x 20 ft maximum, with light-color walls, and equipment that is in good working order, that is, proper shutter synchronization and live batteries in the flashgun. If a room is too large or painted a dark color, it will absorb more light. To avoid the consequent underexposure, the photographer must open the camera aperture by one or two stops. Likewise, if a room is too small and has glossy white walls, it will reflect so much light back to the camera that the resultant picture will be over-exposed unless the photographer closes the lens aperture one or two stops.

Automatic Determination. Recent advances in technology have led to the **automatic exposure** system for electronic flash. Some modern electronic flash units have a sensor built into their housing that not only measures how much light is reflected from the subject but also turns off the flash unit when there is light enough for correct exposure. The photographer need only set a single F/stop, and, as long as the subject is in the range of the unit, the duration of flash will be automatically set for correct exposure.

In lower-priced units, any power left in the storage capacitor of the flash is wasted in the flash of a dummy tube in the flashgun body. A recently developed system, called the **thyristor circuit**, can store unused energy for the next flash exposure. Such units are initially more expensive, but they give longer battery life and shorter recycle times. More expensive units also usually allow the photographer choice of more than one F/stop while in the automatic mode. This feature increases the range of the automatic settings and will also allow the photographer to change depth of field (Fig. 6-10).

Automatic flash units may also be dedicated to a particular camera. These flash units couple with their camera to provide sophisticated exposure control. A dedicated flash connects through the hot shoe of the camera. Through this connection, the camera will signal the flash the ISO of the film and the F/stop in use. In return, the flash will signal the camera to adjust the shutter to the proper synchronizing speed regardless of the actual camera setting. During the camera exposure, the dedicated flash will determine the duration of its flash by means of a sensor giving an automatic exposure. When the flash is turned off, the shutter speed control reverts to the camera. Dedicated flash systems are also produced for special cameras. These couple with a behind-the-lens meter that also reads flash exposure. With these units, the amount of light passing through the camera lens controls the exposure, allowing exposures without adjustments due to bellows or filter factors (Fig. 6-11).

Figure 6-10 Automatic thyristor electronic flash. (Courtesy of Vivitar Corporation)

Figure 6-11 A dedicated flash system reading exposures from the behind-the-lens meter in the camera. Electronic circuitry connects the flash and the camera. The flash can therefore interact with the camera to determine and set the correct exposure.

Flash Technique

Single-Flash Setup. Most photographers use a single-flash setup, usually mounted right on the camera body for convenience. Pictures taken with such an **on-camera flash** setup are commonly one-dimensional and artificial looking.

On-camera flash setups are subject to an equally bad side effect called *red eye*, in which light reflected from within the subject's eyes back to the film makes the eyes in the resulting photo appear to glow red (Fig. 6-12). Red eye can be corrected in two ways. If the flash is permanently mounted on the camera, as in some instant-load cartridge cameras, having the subject look slightly away from the camera will prevent the retinal reflections from reaching the camera lens.

The better way to correct for red eye, and to create better-looking pictures as well, is to remove the flash from its camera mounting and to place it on a bracket or some other support away from the camera. In addition to preventing red eye, this off-camera

Figure 6-12 On-camera flash systems can yield photos exhibiting red eye and harsh shadows.

Figure 6-13 Off-camera flash produces a much more natural-looking picture.

flash gives a more natural kind of lighting, adds roundness to the subject, and can be just as convenient as on-camera flash (Fig. 6-13).

Bounce Flash. Another type of natural lighting is **bounce flash**. If flash light is bounced off a convenient, neutral-colored surface such as a wall or ceiling, the light that reaches the subject will be diffuse and will create much less contrast, thus yielding a photo that looks as though it were taken outdoors in diffuse lighting. It is important for the reflector to be a neutral color, for whatever the color of the reflector, that will be the color reflected to the subject.

We determine proper exposure differently when bounce flash is employed. Instead of dividing the guide number by the distance from flash to subject, the divisor is the distance from flash to reflector *plus* the distance from reflector to subject. The amount of light absorbed by the reflector must also be taken into account. The proper F/stop may be approximated by first dividing the guide number by the total distance from flash to reflector + the distance from the reflector to the subject, and then multiplying the result by 0.7. Automatic electronic flash units, of course, give the correct exposure as long as the sensor is aimed at the subject (Fig. 6-14).

Figure 6-14 Bounce-flash; auto-thyristor electronic flash system. (Courtesy of Soligor AIC Photo, Inc.)

Multiple Flash Setup. When employing a multiple flash setup, you must adjust exposure for the number of main flash units, called **key lights**, which are usually at camera height or slightly above. Only the key lights will affect the exposure required for a scene. All other lights in the setup are **fill lights**. Because they are usually farther from the subject than the key lights, as many fills as necessary may be used.

Two special types of fill lights are **background lights** and **accent lights**. Background lights are aimed at the background so as to fill in shadows; accent lights are aimed at areas to be highlighted. When two or more key lights are involved, the normal guide number for a single key light is multiplied by the square root of the total number of key lights. This amended guide number is then divided by subject distance, as usual, to determine F/stop. Automatic electronic flash units will, of course, compensate and give correct exposure without our having to take the additional key lights into account.

Special Techniques. Open flash technique makes use of the entire output of a flashbulb. Because the shutter for open flash is locked open for an extended period of time, the camera must be placed on a tripod or other support.

The flash and shutter are *not* synchronized for open flash. Instead, the flash is fired after the shutter is opened and once the flash dies, the shutter is closed. If more light is needed, another flash can be fired before the shutter is closed. The technique of overlapping many flash firings on a single frame of film is called **painting with light** (Fig. 6-15).

Figure 6-15 Painting with light combines many separate exposures on a single frame of film. In this case, the camera was mounted on a tripod, and the shutter was left open during four firings of an electronic flash. No image was recorded between the flashes because the scene was photographed at night in total darkness.

Flash may also be used as **fill light outdoors**, to fill in shadows and compensate for backlighting (Fig. 6-16). In this special application, the flash is placed at a distance where it will contribute about one-half to one-quarter as much light as the sun (one to two stops).

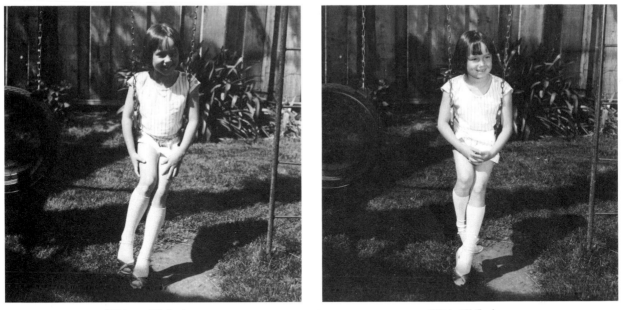

Without fill flash With fill flash

Figure 6-16 Fill flash can supplement natural lighting by filling in shadows and thereby lowering the unnaturally extreme contrast found in some photographs.

Floodlights

Photographic flood lamps are specially designed tungsten lamps that keep their color balance throughout their entire burn life (because they burn out before their color temperature lowers). Floodlight technique is similar to that for flash setups. Key lights, fill lights, accent and background lights all combine to produce correctly exposed pictures.

Flood lamps come in various wattages, from 250 W to 1000 W, and in two color balances for color films—3200°K bulbs, balanced for type B film, and 3400°K bulbs, balanced for type A film. These bulbs need reflectors in order to aim light at the subject.

Broad vs. Short Lighting Setups

There are two basic lighting setups for flash or flood: broad lighting and short lighting. The names refer to how the key lights are placed in relation to the subject. **Broad lighting**, popular for portraits of normal or thin faces and also for product (inanimate subject) photography, uses key light to fully illuminate the aspect of the face or product that is turned toward the camera (Fig. 6-17).

In **short lighting**—commonly used in portraiture to narrow a round or plump face (Fig. 6-18)—the key light fully illuminates the side of the face that is turned away from the camera. Care must be taken not to silhouette an unsightly nose.

Figure 6-17 Broad lighting setup.

a. The key light fully illuminates the side of the face toward the camera.

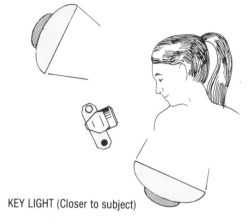

FILL LIGHT (Farther from subject)

KEY LIGHT (Closer to subject)

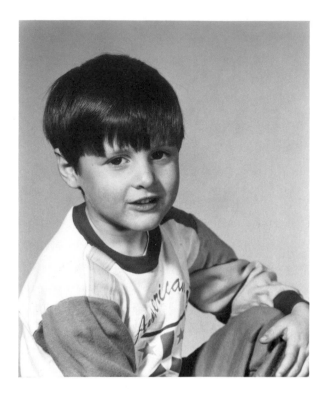

b. A portrait taken with broad lighting. (Courtesy of Maxwell Crumley. The Elegant Image, Santa Clara, Calif.)

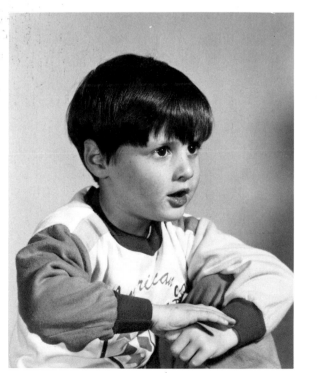

Figure 6-18 Short lighting setup.

a. The key light fully illuminates the side of the face away from the camera.

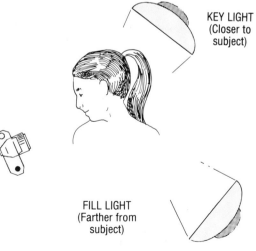

KEY LIGHT (Closer to subject)

FILL LIGHT (Farther from subject)

b. A portrait taken with short lighting. (Courtesy of Maxwell Crumley, The Elegant Image, Santa Clara, Calif.)

Chapter 7
Camera Filters

We can alter the wavelengths of light reaching a camera's film and change the photographic result by placing over the camera lens a transparent, colored material called a filter (Fig. 7-1). The filter's usual position in front of the lens has the advantage of protecting the lens from foreign objects; however, fingerprints, grease, or scratches on the filter have the same detrimental effect as such marks on the lens itself.

Understanding how filters affect the transmission and absorption of different wavelengths requires a knowledge of the primary colors of light.

Additive Colors and Subtractive Colors

There are three **additive primary colors:** red, green, and blue. When light of these three hues is added together—as with three projectors focused on a white surface to form three circles—the result is white light at the center (Fig. 7-2).

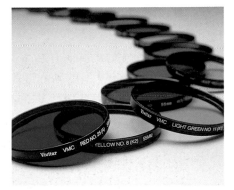

Figure 7-1 Camera filters. Colored filters of the type displayed may be used to change the tones in the final photographic image.

Figure 7-2 The three additive primary colors (red, green, and blue) add to produce white light. Two additive colors together produce a subtractive (complementary) hue.

Adding together light of any two of the primary colors yields other hues. For instance, blue light and green light added together produce a blue-green called cyan; blue light plus red light yields a purplish hue called magenta; and the mixture of red and green light results in yellow. These combination hues are known as **subtractive primary colors** because combining all of them acts to take color away, yielding neutral gray or black. Subtractive colors are also known as **complementary** or **minus-colors** of the additive primaries. For instance, because cyan consists only of the primaries blue and green, it is called minus-red, or the complement of red. Similarly, magenta is minus-green, and yellow is minus-blue.

A filter can never add colors absent in the original light. Rather, it will pass its own additive hue(s) and absorb all other hue(s).

Types of Filters

Filters can be broadly divided into three categories: correction filters, for color film only; contrast filters, for black and white film only; and special-purpose filters, for either black and white or color film.

Correction Filters (for color film only). Daylight has a greater percentage of blue in it than most artificial light, which has a greater proportion of red (Fig. 7-3). For this reason, daylight color film exposed indoors produces photos with a reddish cast, and indoor color film exposed outdoors yields bluish photos.

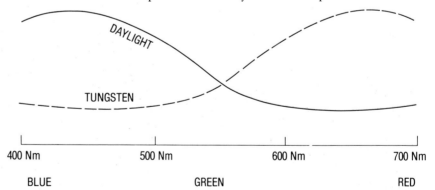

Figure 7-3 Daylight contains more blue radiation than does tungsten-filament illumination.

One way of correcting the color imbalance that results when color film is used in the wrong lighting is to place a correction filter over the camera lens. Thus, when shooting indoors with outdoor color film, we can compensate for the lack of blue light by adding a blue filter during exposure. On the other hand, when working outdoors with indoor color film, we can correct for the lack of red light with a red-orange filter (Fig. 7-4). All such color correction filters are of a very pale hue. Exactly which filter to use can be determined from Table 7-1.

Figure 7-4 Correction filters.

a. Daylight film used indoors without the proper correction filter. Notice the overall orange cast.

b. The same indoor scene photographed with daylight film and an 80A correction filter.

TABLE 7-1
SELECTING A COLOR CORRECTION FILTER

Film Type	Lighting	Filter No.
Daylight	3400°K	80B
	3200°K	80A
A	Daylight, blue flash, or electronic flash	85
	3200°K	82A
	Clear flashbulbs	81C
B	Daylight, blue flash, or electronic flash	85B
	3400°K	81A
	Clear flashbulbs	81C

Contrast Filters (for black and white film only). Contrasting colors in a beautiful scene often do not photograph well in black and white because the images of subject and background blend into a monotonous gray. We can enhance contrast in black and white photographs by using contrast filters (Fig. 7-5).

Contrast filters, unlike correction filters, come in many colors and are quite dark. Their exact photographic effect can be predicted with the following rules of thumb for panchromatic film (Fig. 7-6).

● The color that is complementary to that of the filter will be darkened the most.

● Colors similar to the complementary color will be darkened only somewhat.

● The filter's own color will be lightened the most.

● Colors similar to the filter color will be lightened only somewhat.

For example, take a scene of a red flower against a green background (Fig. 7-7). Photographed through a red filter the green background reproduces as a darker gray than expected, and the red flower reproduces almost white.

Because contrast filters have the power to lighten tones in black and white photographs, they can effectively "remove" stains when photographing a stained document, using a filter of the same color as the stain. For example, a red stain on a black and white document photographed through a red filter will blend into the background of the print (Fig. 7-8).

Yellow, green, and red are the most common contrast filter colors. It is sometimes stated—incorrectly—that a yellow filter produces "true" tones on panchromatic film. In fact, a yellow filter

Figure 7-5 Contrast filters.

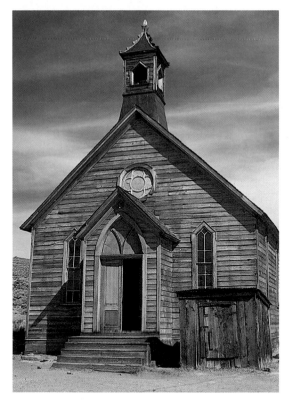

a. Normal color photograph.

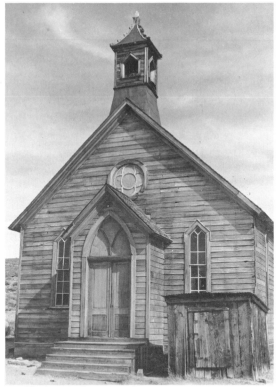

b. Black and white print from a negative exposed without a contrast filter.

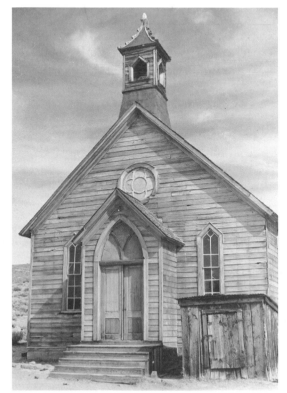

c. Black and white print from a negative exposed with a yellow contrast filter.

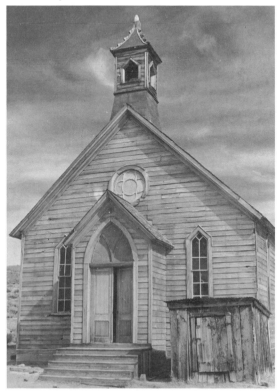

d. Black and white print from a negative exposed with a red contrast filter.

Figure 7-6 Rules of contrast filters.

a. Black and white print from a negative exposed without contrast filter. The various shades of gray produced by different colors can be seen on the accompanying gray card.

b. Black and white print from a negative exposed with a yellow contrast filter. Notice the changes in the patches on the gray card.

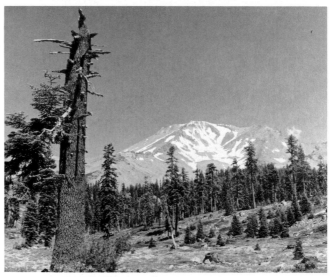

c. Black and white print from a negative exposed with a red contrast filter. Notice the changes in the patches on the gray card.

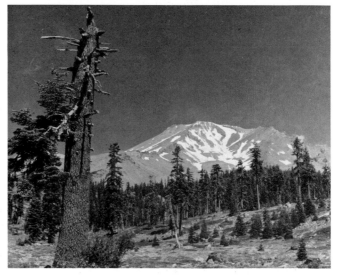

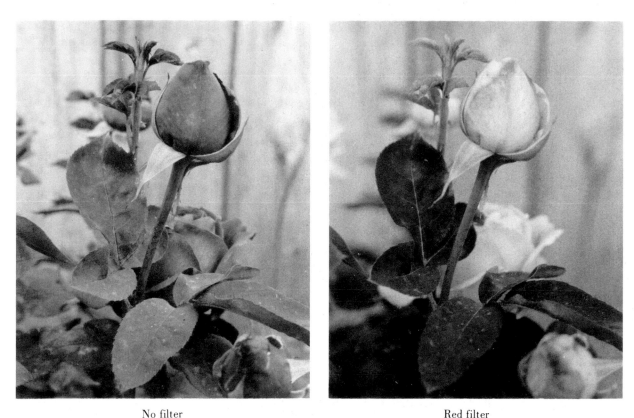

No filter Red filter

Figure 7-7 The contrast in a black and white print between the red flower and the green background is enhanced by photographing the scene through a red contrast filter.

No filter Red filter

Figure 7-8 The intensity of a red stain was diminished by photographing the stained document in black and white through a red filter that was close to the same color as the stain.

will bias the black and white photographic result by darkening a cyan sky and lightening yellow objects. Table 7-2 lists print results for red, green, and yellow filters.

TABLE 7-2
EFFECT OF CONTRAST FILTERS ON BLACK AND WHITE
PHOTOGRAPHS

Filter Color	Subject Color	Print Result
Red	Red	Lightest
	Magenta	Lighter
	Yellow	Lighter
	Cyan	Darkest
	Blue	Darker
	Green	Darker
Green	Green	Lightest
	Yellow	Lighter
	Cyan	Lighter
	Magenta	Darkest
	Red	Darker
	Blue	Darker
Yellow	Yellow	Lightest
	Red	Lighter
	Green	Lighter
	Blue	Darkest
	Magenta	Darker
	Cyan	Darker

Contrast filters produce their effects because they are able to selectively transmit or absorb particular wavelengths (Table 7-3).

TABLE 7-3
SELECTIVE TRANSMISSION / ABSORPTION

Filter	Passes	Absorbs
Red	Red	Blue and green
Green	Green	Blue and red
Blue	Blue	Red and green
Magenta	Blue and red	Green
Yellow	Red and green	Blue
Cyan	Blue and green	Red

Where colors are passed by a filter, the film will be exposed with considerable density, and these colors will therefore appear lighter on the print. Where colors are absorbed by the filter, the film will not be exposed, and these colors will appear darker on the print.

Special-Purpose Filters (for black and white or color film).

There are filters for special photographic purposes. This section will discuss five of them: polarizing filter, ultraviolet filter, neutral-density filter, soft-focus filter, and star-effect filter.

Polarizing Filter. As mentioned in Chapter 1, specular glare light is polarized. Such glare light can be absorbed by a polarizing filter. The polarizing filter can be adjusted to block glare light while allowing image-forming light to pass (Fig. 7-9).

The polarizing filter reduces glare for black and white film and for color film (Fig. 7-10). It can also serve an additional purpose for color film—it is the only kind of filter that will darken skies on color film (because sky light is a partially polarized light) (Fig. 7-11). Contrast filters, being so dark in hue, cannot darken the sky with color film; they will only distort the color. A red contrast filter, for instance, would turn all colors in the final print or slide to red.

Ultraviolet (UV) Filter. All photographic materials are sensitive to ultraviolet (UV) radiation, while the human eye and light meters are not. An excess of UV radiation will overexpose both black and

Figure 7-9 Polarizing filter. Parallel alignment of a polaroid filter. To increase the polarizing filter's effect of blocking polarized light, the filter is rotated around the lens axis. Maximum effect is achieved when the parallel material in the filter is perpendicular to the polarization of the radiation.

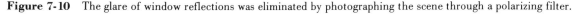

No filter Polarizing filter

Figure 7-10 The glare of window reflections was eliminated by photographing the scene through a polarizing filter.

Figure 7-11 Exposing color film through
a polarizing filter can darken the sky and
reduce reflections in the finished photo.

No filter

Polarizing filter

white and color film. With color film, however, there is another affect: Ultraviolet radiation overemphasizes blue and under emphasizes yellow, giving the final print or slide a bluish cast.

Although the glass, glues, and coating of modern lenses will absorb some of the UV radiation, an ultraviolet absorption filter will block the rest and still pass only visible radiation to the photosensitive material. Because a UV filter in no way affects the visible image, it is an excellent choice for placing over any lens to protect the lens from fingerprints, sea spray, or harmful materials.

Neutral-Density Filter. The neutral-density filter is especially useful with high-speed film because it reduces the intensity of the transmitted light without altering the color. It also enables the photographer to set a wider aperture for the creative effect of shortened depth of field.

Soft-Focus Filter. A soft-focus filter is a useful accessory for portraits. It acts to blend shadows, minimize skin blemishes, and diffuse the background (Fig. 7-12).

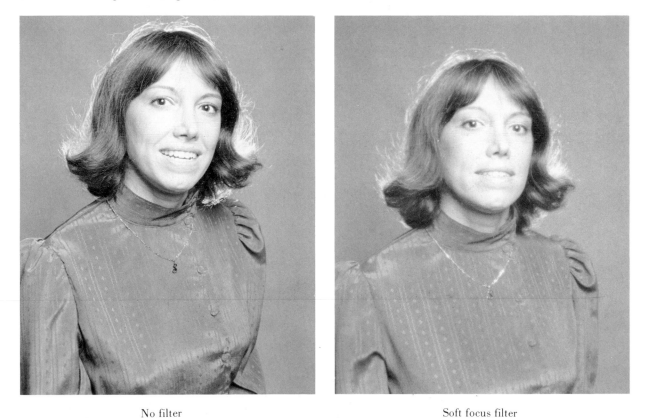

No filter Soft focus filter

Figure 7-12 A soft focus filter, by diffusing the image, can help produce pleasing portraits. (Courtesy of Donald B. Rex)

Star-Effect Filter. The star-effect filter has cross grids that create starry highlights with point sources, an effect appropriate to only certain subjects (Fig. 7-13).

Figure 7-13 The result of a star-effect filter. (Courtesy of Donald B. Rex)

Filter Factors

Because filters produce their effects by absorbing selected wavelengths of light, underexposure is an obvious potential side effect (Fig. 7-14). Fortunately, this compensatory change in exposure can be estimated with a **filter factor**, which comes packaged with every filter. This factor tells us the number of times that exposure must be increased over the metered or 1/ISO determined exposure. For instance, a filter that has a 2X filter factor would demand double the exposure—opening the aperture by one stop or slowing the

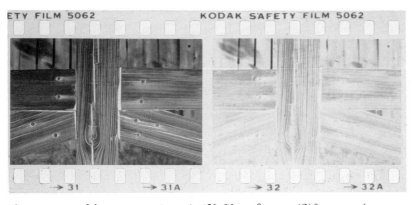

shutter speed by one setting. A 4X filter factor $(2)^3$ means increasing the exposure by two settings. An 8X filter factor $(2)^2$ necessitates a three-setting increase in exposure. The change in settings can involve either F/stop or shutter speed or both. Which equivalent exposure to choose depends on whether depth of field or subject motion is the more important consideration.

Filter Quality

Filters vary in optical quality. Gelatin and plastic filters, which are low in quality, should be used with low-quality lenses only. A higher-quality gelatin filter can be made by sandwiching a gelatin sheet between two sheets of optical glass. Unfortunately, such a filter has two disadvantages: The constituent layers can separate, and the colored gelatin fades quickly.

The highest-quality camera filters are made from dyed optical glass of either B grade or the higher-priced and higher quality A grade. A good rule of thumb is to choose filters whose quality matches the quality of the camera lens. A filter lower in quality than the lens will degrade the image; one higher in quality than the lens will not improve the photo. Matching filter to lens will also give you the most value for your money.

Chapter 8

The Chemistry of Black and White Processing

Photographic processing uses a series of chemical solutions to first make the latent photographic image visible and then to make this visible image permanent. The chemical solutions can either be assembled and mixed by the user or purchased premixed. Understanding the purposes and limitations of these processing solutions will enable the photographer to make informed choices that enhance

Figure 8-1 Extreme closeup of a photographic negative. In the developing process, exposed silver ions are reduced to silver metal (black patches). The clear areas of the negative (white areas) were not exposed, so no metal was produced. (Courtesy of Eastman Kodak Co.)

the final product. Proper use of the various photographic processing chemicals will yield a technically high-quality image; improper use could ruin an otherwise excellent composition. It is the photographer's responsibility to choose the right chemicals and maintain the proper quality control in order to achieve the desired results.

Photographic developing is a chemical process whereby silver ions (Ag^+) in photographic emulsion are reduced to silver atoms ($Ag°$) by the taking on of electrons from a developing agent (Fig. 8-1). In order to understand processing, let us first discuss the chemical nature of the photographic emulsion.

Photographic Emulsion

The photosensitive compound in photographic materials is an ionic form of silver. The manufacture of photographic emulsion employs a double decomposition reaction in which silver as silver nitrate combines with a bromide, chloride, iodide, or any combination of these halogens to form a photosensitive precipitate of silver halides:

silver nitrate + potassium halide \rightarrow silver halide↓ + potassium nitrate

Potassium nitrate, a valuable by-product in the manufacture of photographic emulsions, is sold to other industries.

With this understanding of the chemical nature of photographic emulsion, we are now ready to discuss the four chemical solutions used to process black and white emulsions: developer, stop bath, fixer, and water wash.

Developer

Regardless of its chemical makeup, a developer's main purpose is to make the latent photographic image visible. At the end of developing, the photographic emulsion contains both reduced silver and unexposed silver halides.

Developing solution contains at least four chemicals: developing agent, preservative, accelerator, and restrainer. **Developing agent** acts primarily to donate the electrons needed to reduce silver halides in the photographic emulsion to visible silver metal. Although any reducing agent will work, certain agents are chosen for their photographic results as well as their relatively low cost, Metol and Hydroquinone being the two most popular. **Metol** works very well to reproduce detail in the shadow area of the image. **Hydroquinone** gives higher contrast and excellent separation of highlight tones. Many developers are a combination of Metol and Hydroquinone. These combination developers, called **MQ devel-**

Figure 8-2 Too high a solution temperature during processing damaged this negative emulsion. Notice the frilling of the emulsion at the edge of the negative strip. (Courtesy of Donald B. Rex)

Hydroquinone alone. **Phenidone** is another developing agent that works well in combination with Hydroquinone. Other developing agents are available for such special effects as warm-toned images or changes of contrast in the shadow or highlight areas of the image.

Preservative is included in the developing solution to slow down its oxidation and thus give it a longer shelf life. Sodium sulfite is the most commonly used preservative; in quantities over of 100 grams per liter, it produces a finer-grained image through a process called **solution physical developing.**

Developing agents and preservatives by themselves will not produce an image, because no developing agent works when it is acidic or neutral. In fact, the higher the pH, the faster a developer works. Therefore, a buffer or **accelerator** is needed to raise the pH to a workable level. Accelerators such as sodium tetraborate and sodium carbonate will buffer most developers to a pH of between 8 and 10.

Developers unrestrained will reduce all silver halides to silver, whether exposed or not. Therefore, a **restrainer** such as potassium bromide or benzotriazole is included in the developer to help it select only the exposed halides for reduction.

Developing Rate. The rate of reduction in developing is controlled by five factors: solution temperature and concentration, amount the solution is agitated, activity level of the developing agent and pH of the developer solution.

Temperature of the developing solution is of major importance and is controlled by the photographer. Normally, the higher the temperature, the faster the photographic image develops. If their temperature is below 65°F, most developing agents will not work without a special low-temperature additive. Most films and paper are designed to be processed in solutions whose temperature is under 80°F. Higher-temperature solutions can physically damage the photographic emulsion (Fig. 8-2). Only those color films that are specially prehardened to prevent such damage can be processed in solutions at 100°F or higher.

The user chooses developer **concentration**, ordinarily on the basis of the manufacturer's recommendation. Many developers are designed to be used undiluted; others may be diluted with water as much as 1:100. The greater the dilution, the weaker the developer solution and therefore the longer the developing time. However, a more dilute developer can give a finer-grained image.

Solution **agitation** is another user-controlled factor. The faster the rate of agitation, the faster the rate of developing and, usually, the stronger the contrast.

Developer agent **activity** level is set in the manufacture and depends upon the type and proportions of constituent chemicals.

Another factor that is fixed in most prepackaged solutions is **pH**. Normally, the higher the pH, the faster the rate of developing. The maximum pH of a developer depends on whether the developer is to function in a hand process or machine process. To increase speed, most machine processing takes place at higher pH. For the safety of the user, hand-processing solutions are lower in pH (pH 8 to 10).

Stop Bath

A stop bath or water rinse is employed after developing but before fixing. Being acidic, a stop bath immediately stops the action of the developer. It has the added advantage of limiting any contamination by carryover of developer to the fixing bath, the next processing step.

Fixer

Fixer acts to dissolve the unexposed, unreduced silver halides, which would turn the image completely black if allowed to remain in the emulsion. The fixer chemical is either sodium thiosulfate (for hand processing) or ammonium thiosulfate (for machine processing because of its faster action). Potassium alum is incorporated in most fixing baths to harden the emulsion and protect it from physical damage during the remainder of processing.

Fixing Rate. The rate of fixing photographic emulsion is controlled by many of the same factors that control the rate of developing: solution temperature, concentration, and activity level and amount the solution is agitated.

Fixer **temperature**, a user-controlled factor, should be similar to developer temperature so as to protect against apparent graininess in the image (reticulation) (Fig. 8-3). **Concentration** of the fixing bath is determined by the manufacturer; most fixers are used undiluted. Fixer **activity** level varies with the chemical composition of the fixing agent. Sodium thiosulfate will fix an emulsion in 6 to 10 minutes; ammonium thiosulfate takes from ½ to 4 minutes. Ammonium thiosulfate, however, is more expensive. No matter which type of fixer is used, agitation will decrease total fixing time.

Fixation must be done with careful control, because underfixing produces an image that gradually turns black, and overfixing not only dissolves unreduced silver halides, but begins to dissolve the silver image itself. Overfixed images start to fade quite rapidly and will ultimately disappear completely.

Fixers may be tested to warn the user when the chemical is exhausted. A drop of hypo-test solution is introduced into the fixer. If a cloudy white precipitate forms, the fixer is too weak and should be replaced.

Figure 8-3 Reticulation (or apparent graininess) in this negative was caused by a difference in temperature between developing bath and fixer. (Courtesy of Donald B. Rex)

Water Wash

Because fixer would act to gradually fade a developed image, unused fixer and the by-product of fixing must be water washed from any photographic material. To shorten what is otherwise a time-consuming step (at least an hour for most films and up to two hours for certain print papers), washing aids are employed. These chemicals break down the long-chain molecule of the fixer's by product and in this way increase surface area for more rapid removal of the fixer.

Solution Storage

The shelf life of prepared photographic chemicals is limited and can be greatly reduced by improper storage. Oxidation of the chemical baths can be reduced by storing them in full, tightly closed bottles and protecting them from direct light. Temperature can also be a problem in the storage of photographic chemicals. Too low a temperature can cause the solutions to crystallize; too high of a temperature will further the possibility of rapid oxidation. The best temperature for chemical storage is between 65° and 75°F.

Chapter 9
Black and White Film Processing Technique

Until well into the present century, photographers relied on visual inspection for determining exactly when processing was complete. The film was developed under a safelight (that is, a light consisting of wavelengths to which the film was insensitive) so the photographer could decide by inspection when to cease the developing.

The introduction and widespread use of panchromatic materials made safelight inspection impossible, and control of temperature and duration became the technique of choice for developing black and white negatives. At about the same time, different contrast grades of printing paper came on the market, making it unnecessary to develop to a fixed density and contrast range. Thus, duration of developing, temperature of the developer, and agitation of the solution became the three most important factors for every film-developer combination (Fig 9-1).

Duration

Just how long to develop a negative depends not only on the film-developer combination but also on the developer temperature and its rate of agitation. Although film and developer come packaged with useful timing guidelines, some users consistently shorten or lengthen the recommended times to suit their own preferences for contrast in the negative.

Figure 9-1 Materials necessary for film processing.

Solution Strength. Film can be processed in developers that are full strength or diluted. Although diluted developers generally give the maximum sharpness obtainable from a particular type of film, they must be discarded after only one use. Full-strength developers, on the other hand, can be replenished and reused indefinitely, and they usually work faster.

Temperature

The usable temperature of most black and white developing solutions ranges from 65°F to 75°F (20°C to 24°C) although developing at the extremes of this range can spoil the visual appearance of the negative. The lower the developer temperature, the longer the developing time required. Raising the temperature shortens developing time (Table 9-1).

Table 9-1
DEVELOPING TIME FOR VARIOUS TEMPERATURES OF DILUTED 1:1 D-76 DEVELOPER*

Developer Temperature	Verichrome Pan	Plus X and Panatomic X	Tri X	T Max 100 & 400
65°F	11.0 min.	8.0 min.	11.0 min.	14.5 min
66°F	10.5 min.	7.5 min.	10.5 min.	13.5 min
68°F	9.0 min.	7.0 min.	10.0 min.	12.5 min
70°F	8.0 min.	6.5 min.	9.5 min.	11.0 min
72°F	7.5 min.	6.0 min.	9.0 min.	10.0 min
74°F	7.0 min.	5.5 min.	8.5 min.	9.0 min
75°F	6.5 min.	5.0 min.	8.0 min.	8.5 min

Times shown are for small tanks and assume one 5-second agitation every 30 seconds.

Below 65°F, most developers cease to function and thus form no image. Above 80°F, the emulsion can separate from the film base.

Ideally, all processing solutions are kept at approximately the same temperature so as to avoid reticulation (apparent graininess) in the negative and print (Fig. 9-2).

Agitation

Agitation should begin as soon as any chemicals contact the film and should be maintained at a repeatable rate throughout. Increasing the agitation rate will overdevelop the negative and can produce dark streaks along its edges that show up as white streaks on the edges of the print. Underagitation yields an underdeveloped negative that is low in both density and contrast (Fig. 9-3).

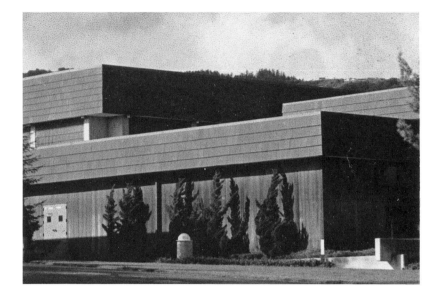

Figure 9-2 The apparent graininess of this print is caused by reticulation during processing of the negative. See Figure 8-3. (Courtesy of Donald B. Rex)

Figure 9-3 Effect of agitation on negative density and contrast. (Courtesy of Robert Buck)

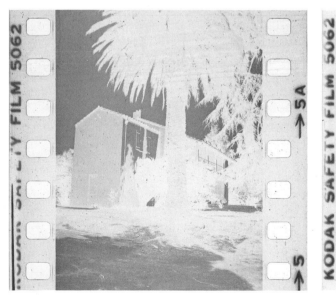

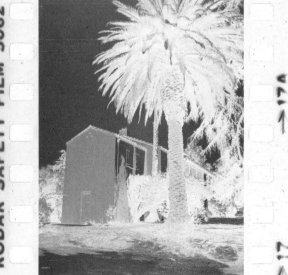

a. Underdevelopment caused by under-agitation.

b. Overdevelopment caused by over-agitation.

Processing Tank

The most popular procedure for processing roll film employs a tank, with the film held in place by a spiral reel or apron the same width as the film. The following section details the procedure for tank-processing of black and white film.

PROCEDURE FOR TANK-PROCESSING OF BLACK AND WHITE FILM (Refer to Fig. 9-4)

1. **Load** the film into the tank **(remember to load the tank in total darkness).**

Developing

2. **Assemble** the processing **chemicals** into labeled containers. This will prevent contamination among chemicals and help ensure that they are added to the tank in the correct order.
3. **Adjust** the **temperature** of each solution to the proper level.
4. On the basis of the developer's time-temperature chart, determine the correct **developing time** for its temperature.
5. **Set** a **timer** for the selected duration, and immediately and quickly fill the tank **with developer.**
6. **Rap** the **tank** on the bottom of the sink (to dislodge any air bubbles that might be present on the film surface), **and agitate** for the first 30 seconds and for 5 seconds every 30 seconds thereafter. This ensures that fresh developer is always in contact with the surface of the film.
7. Total developing time includes drain time, so just before the end of the preset developing time, invert and **drain** the **tank.**

Stop Bath

8. **Fill** the tank **with stop bath** or water.
9. **Rap** the tank to dislodge any air bubbles **and agitate** it continuously for 30 seconds.
10. Invert and **drain** the tank.

Fixing

11. **Fill** the tank **with fixer.**
12. **Rap** the tank once again, **and agitate** it for the first 30 seconds and for 5 seconds every 30 seconds thereafter.
13. Just before the end of the manufacturer's recommended fixing time, **drain** the tank. (Excess time in the fixer will bleach the image.)
14. To shorten the required wash time, you may **add** a **hypo neutralizer** solution. **Drain** the **tank** after the manufacturer's recommended neutralizing time.

Figure 9-4 Processing steps.

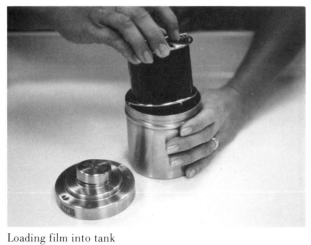

Loading film into tank

Adding chemicals

Checking temperature

Rapping tank to dislodge air bubbles

Agitation

Washing

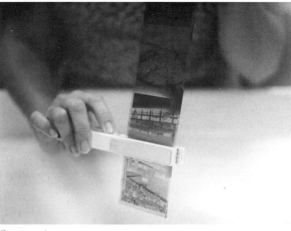

Squeegeeing

Washing

15. **Fill** the tank **with water,** and overflow for 10 minutes to remove the by-products of fixing. If you do not replace the water about once a minute during the wash, extend total wash time should to 15 minutes. If a washing aid such as hypo neutralizer was *not* used, total wash time will be ½ hour with overflow.
16. At the end of the wash, **apply** a **wetting agent** to the film, and remove it with a clean squeegee.

Drying

17. **Hang** the film **to dry** in a clean and dust-free area. To speed the drying you can heat the film (no hotter than 100°F).

After Drying

18. **Cut** the dry negatives into **strips.**
19. **Store** the negatives **in protective envelopes.** This will keep them clean and free of scratches for later proofing and printing.

Intensifiers and Reducers

If a completely processed and dried negative turns out either too light or too dark, the error in density can be partially corrected by bathing the negative in certain chemicals. A light negative can be darkened with a chemical **intensifier,** which adds particles of chromium or mercury on top of the image silver already present. Because darker areas receive more of the new metal, contrast is intensified. A negative that is too dark may be treated with a **reducer,** which acts to dissolve the silver in the darkest areas of the negative, making the negative more transparent and thus more printable.

Intensifiers and reducers can compensate not only for errors in developing but for errors in exposing film, as well. Neither chemical agent, however, will succeed if the errors being corrected are extreme.

Checklist for Successful Film Developing

☐ Make sure the tank and reel are clean and **DRY.**

☐ Be sure your thermometer is accurate.

☐ Load tank in **total darkness, no safelights!**

☐ Use only fresh chemicals.

☐ Be sure all the solution temperatures are the same. Tap water temperatures may vary. Temperature differences between steps may cause reticulation.

☐ Make sure the mixing container used for developer solution is accurate. Check suggested concentration as per manufacture's recommendation.

☐ Determine the developing time by checking a time-temperature chart for your film and developer.

☐ Follow the tank manufacturer's agitation instructions.

☐ Do not over fix.

☐ Use a clean squeegee and proper pressure to be sure you don't damage the emulsion.

☐ Do not dry your film at temperatures above 100°F.

☐ Store your negatives carefully.

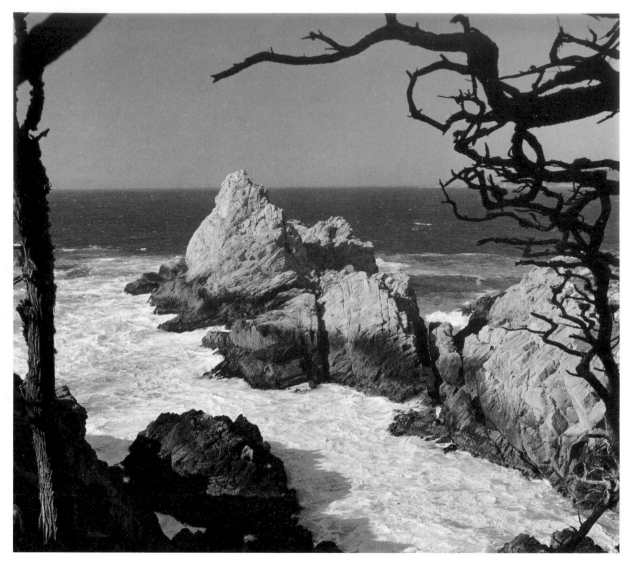

This photograph of Point Lobos, California, was taken at 1/60 F/16 on Kodak Plus X Pan Professional film and demonstrates some of the techniques of previous chapters. A medium yellow filter was used over the camera lens at the moment of exposure to heighten the contrast between the sky in the background, and trees in the foreground. Dodging the lower half of the print 60% of the printing time kept that area from becoming too dark.

Chapter 10
Black and White Projection Printing and Print Finishing

Once black and white film negatives have been prepared, the task of producing prints begins. This chapter will discuss print paper, projection printing equipment and, print exposure, processing, and finishing.

Print Paper

Although black and white photographic printing paper varies in many of its physical characteristics, most papers conform to the cross-sections in Figure 10-1. It is up to the photographer to choose a print paper that correctly completes the composition begun with the camera.

Paper Base. Many of the final characteristics of photographic prints depend on the weight of the print paper, which in turn is a function of the thickness of the woodpulp paper base. Papers come in four basic weights—single, double, light, and medium.

Single-weight paper, which is fiber based, is lowest in cost but tends to curl after drying and can be easily damaged by improper processing. **Double-weight paper,** also fiber based, will lie much flatter after processing. Although not as susceptible to processing

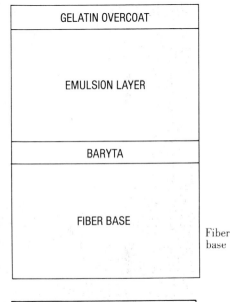

GELATIN OVERCOAT

EMULSION LAYER

BARYTA

FIBER BASE

Fiber base

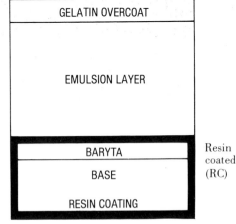

GELATIN OVERCOAT

EMULSION LAYER

BARYTA

BASE

RESIN COATING

Resin coated (RC)

Figure 10-1 Cross sections of photographic print paper.

damage as single-weight paper, double-weight paper is much more expensive.

Medium-weight paper is resin coated (RC). RC is thin fiber base is coated with polyethylene, a synthetic thermoplastic material that makes its paper base somewhat impermeable to water and greatly inhibits the print's tendency to curl while drying. The nonabsorbent coating also significantly reduces the time needed for processing, washing, and drying. Accurate timing of the developing process with RC, is however, very important. RC paper is manufactured in large rolls and then cut into sheets. Therefore, liquid can be absorbed through the cut edges of the paper and cause the print to curl or perhaps separate.

Unfortunately, RC prints are not as stable as standard fiber-based prints, because both heat and light tend to fade images on these emulsions. For this reason, RC prints are used by the photofinisher and the print media whenever processing speed but not archival quality is essential.

Light-weight papers are special types of fiber-based papers used for specific situations. Light-weight paper being thin and flexible due to an extremely thin baryta layer, is especially useful when a photographic print must be bent or folded.

Base paper can also be tinted to give either a warm or cold tone to the final print. Warm-toned paper is most suited for portraits or the like; cold-toned paper is better for most pictorial prints and all photographs intended for reproduction.

Sizer. Baryta is the material used to **size** a paper, that is, provide a smooth surface on which to coat the photographic emulsion. Although this mixture of barium sulfate and gelatin acts mainly as a sizer, it can also affect the final print. For instance, texturized baryta, produces a print surface that looks like silk, canvas, pebble or other textures (Fig. 10-2).

To brighten and whiten prints, fluorescing dyes can be added to the baryta layer. These dyes fluoresce ultraviolet as blue light which will absorb the natural yellow color of the paper base. Baryta can also be tinted to give a color tone to the final print.

The baryta layer is responsible for the high gloss associated with certain prints. Such glossy prints have a thick baryta layer, which becomes glossy during drying. Matte prints contain a thin layer of baryta (plus any desired additives) that acts only as a sizer. RC baryta-layer paper that is preglossed by the manufacturer need not be glossed during drying.

Figure 10-2 Enlarged samples of textured black and white photo papers.

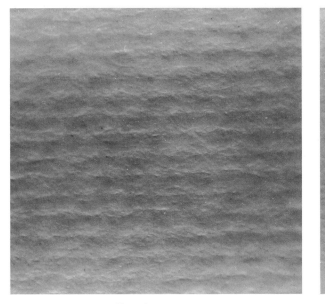

G surface Y surface

X surface R surface

Emulsion Like the emulsion found on photographic film, the emulsion layer of black and white print materials consists of silver halides suspended in gelatin. Usually, only silver bromide, silver chloride, or a combination of these halides is present in print emulsion, because silver iodide is much too light sensitive for a print exposure of many seconds. Silver chloride, the least sensitive of all halides found in modern emulsions, is generally used only in contact printing paper, where great sensitivity is not required. Chlorobromide emulsions, which are popular for projection printing, contain both silver bromide and silver chloride. These emulsions gain sensitivity as greater proportions of bromide are used. Because of their high sensitivity to light, emulsions containing only silver bromide are reserved for photo murals.

The color of the resultant print may also be effected by the choice of silver halides used in the photographic paper. Silver Chloride emulsions usually result in cold toned (blue-black) images, while the addition of silver bromide will cause the print to produce warmer tones such as cream or brown black.

Overcoating. To protect a print from abrasion during processing, the emulsion layer of photographic paper can receive an overcoating of gelatin. A scratch in this overcoating will not show as badly as a scratch in the emulsion layer itself, where it would remove silver. Nevertheless, even with paper that has an overcoating, it is important that care be taken during processing.

Contrast Grades. Contrast in the final print is a function not only of the contrast in the negative but of the contrast grade of the printing paper as well. Papers come in two contrast varieties—graded (a single contrast response) and variable (many contrasts).

Graded paper is monochromatic in response (sensitive only to blue light), and produces only one contrast grade for each grade of paper, numbered from 0 - 6, with no. 2 being normal grade. Paper with a contrast grade lower than 2 is low-contrast paper, best used with negatives of higher than normal contrast. Grade 2 paper is appropriate to normal negatives. Paper with a contrast grade higher than 2 is best suited to low-contrast negatives. Because graded paper is monochromatic, any nonblue safelight can be employed, with yellow being the most popular color.

Variable-contrast printing paper is orthochromatic (sensitive to blue and green), which makes it capable of altering the contrast of a negative. Two halides are mixed together in the same emulsion layer—a monochromatic halide (sensitive to blue) with a high-contrast response and an orthochromatic halide (sensitive to blue and green) with a low-contrast response. Because both halides are

blue-sensitive, the orthochromatic halide is coated with a yellow dye to make it insensitive to blue (blue light cannot pass through the yellow coating). Exposing variable-contrast paper with different colors of light will expose either one or both of the halides, thereby giving a print of the desired contrast range.

Filters are a convenient way to alter the color of light being used to expose variable-contrast paper. For instance, light passed by a yellow filter (which lets through green light and red light while absorbing blue) will expose only the green-sensitive halide and thus produce a print with lower than normal contrast. Light passed through a magenta (blue + red) filter will expose only the blue-sensitive halide, yielding a print with higher than normal contrast. It is possible to use a filter during only a portion of the total exposure time to produce a subtle contrast correction.

Variable contrast paper practically eliminates the need for stocking a lot of different grades of paper in the darkroom. Most variable-contrast papers will produce grades 0–5 prints, however, they are not available in all print surfaces. In order not to fog the print, variable-contrast papers demand a special safelight that will pass no blue or green light into the darkroom.

Projection Printing Equipment

Three basic pieces of equipment (as well as some accessories) are needed for projection printing: the printer, the lens, and the negative carrier.

Projection Printers. The **projection printer,** or enlarger, is a camera that can make an enlarged (or reduced) print. The print will be enlarged when the image distance is greater than the subject distance. Light is projected uniformly through the negative and focused by the lens (at the new size) onto printing paper.

There are two types of projection printers, the diffusion printer and the condenser printer, which differ in their method of distributing the light over the negative and in the resultant prints (Fig. 10-3).

Diffusion Printer. In the **diffusion printer**, light is scattered by means of a diffusion glass placed between the light source and the negative. The diffuse light produces an image of lower contrast and slightly less sharpness. Because a softer image minimizes negative graininess as well as imperfections in both the subject and negative, the diffusion printer is especially good for portraits.

Unfortunately, the diffusion-printer image cannot be sharpened should a sharp image be desired. The diffusion system is also less efficient than the condenser printer. Because a lot of exposing light

is absorbed by the diffusion system, longer exposure times are required. These longer exposures produce extra heat that can warp the negative during exposure and thus yield prints out of focus. Some diffusion printers attempt to solve this overheating problem by adding a heat-absorbing filter to the printer's optical system.

Condenser Printer. The **condenser printer** is the more popular type of projection printer. It focuses incident light on the negative by means of condensing lenses in the lamp housing. Light rays reach the negative parallel to one another and thus produce an extremely sharp image with a nice range of contrast. Unfortunately, the image is so sharp that imperfections in the negative such as graininess, lint, scratches, or dust are reproduced in the print.

Because the light travels only through clear glass and the negative to reach the print, the condenser printer is highly efficient. It uses a lower-power projection lamp, so the problem of warped negatives is minimized. An image projected through a condenser system can be diffused by means of a special diffusion attachment located between the projection lens and the printing paper.

Figure 10-3 Projection printers.

OPTICAL DIFFUSERS

CONDENSING LENSES

PROJECTION LENS

Diffusion printer Condenser printer

Projection Lenses. No matter what type of printer is used, it is the projection lens that will ensure a sharp image. Unfortunately, many photographers who spend a great deal of money on other darkroom equipment still try to skimp on their printer's optical system. Perhaps the best rule of thumb is to use a printer lens of the same quality as your camera lens (Fig. 10-4).

The projection printer lens must at least be anastigmatic and formulated to achieve good resolution and a flat field. A camera lens will not produce good images for projection, because it is not designed to work well at extremely short lens-to-subject distances. The projection lens should be coated and have a fairly large relative aperture for focusing images on the base board of the printer. A useful feature for the low light of the darkroom is click stops, which help you know the particular F/stop in operation.

Negative Carriers. Because a projection lens is designed to produce sharp images on a flat surface, it is imperative that the negative be held perfectly flat in the focal plane of the projection printer. Two types of **negative carriers** one without and one with glass are currently available that serve this purpose (Fig. 10-5).

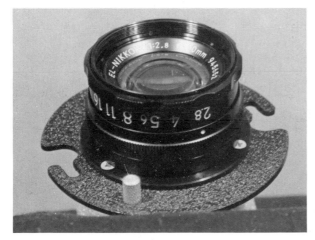

Figure 10-4 A projection lens on enlarger lens board.

Figure 10-5 Projection printer glass and glassless negative carriers.

The **glassless carrier** is the more common type of negative carrier. It is lower in price and does an excellent job with a condensing printer. Because the glassless carrier holds a negative by its edges only and not over its entire surface, it should not be used with a diffusion printer, where heat from the printer might warp the negative out of focus during exposure. A different size glassless carrier is required for each size of negative.

The **glass carrier** holds the tire negative in a sandwich of optical glass, guaranteeing that the negative will never warp out of

focus as can easily happen when using a diffusion printer. However, the glass carrier is much more expensive and more easily broken than the glassless carrier. A glass carrier must also be kept clean to avoid printing any marks that might otherwise be on the glass. To prevent nonimage light from fogging the printing paper, every size of negative must be sandwiched in a matching size mask.

Print Exposure

The final result of photographic printing is a function of the exposure of the print, including the actual exposure time, the contrast of the print paper (discussed earlier in the chapter), special print exposing techniques, and special processing.

Exposure Time. The actual exposure of the print is normally controlled by the use of a darkroom timer (Fig. 10-6). Proper exposure time can be determined by either a guess, a graded test, or a special darkroom light meter called a photometer. **Guessing** at exposure time is, of course, the least reliable method and is usually the most costly because so much expensive photographic paper can be wasted.

The geometric **graded test** is a very effective way to gauge exposure time; it is also the least expensive. In a graded test, a small strip of projection paper is positioned under an important area of the image as exposures of different duration are projected onto the strip. The best exposure is then selected from the choices on the processed strip (Fig. 10-7). The following section details the graded test.

Figure 10-6 Synchronous and electronic photographic print timers.

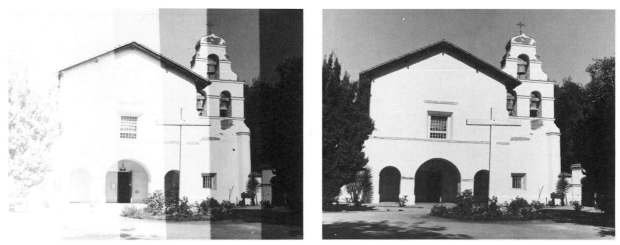

Graded test Final print

Figure 10-7 The graded test was exposed for 1, 2, 4, 8, 16, and 32 seconds at F/16. A study of the processed test determined an exposure of 11 seconds at F/16 for the final print.

GRADED TEST FOR PRINT EXPOSURE TIME

1. Raise the enlarger to a height that will produce a normal 8-in. x 10-in. print. Use a grade 2 paper or a #2 filter with variable contrast paper, attach a lens with the same focal length as normal for the camera that originally exposed the film, and close the aperture to F/16.

2a. *If you already have a proof sheet:* Determine the correct exposure for a projection print by projecting the negative (emulsion side down) onto the easel. Proceed to Step 3.

2b. *If a proof sheet has not been prepared:* Sort the strips of negatives into groups with somewhat similar densities. DO NOT cut the strips. Under suitable safelight, place the negative strips side by side, emulsion side down against the emulsion side of the paper. Cover the negatives and paper with a sheet of glass.

3. To test the print paper for *total* exposure times of 1, 2, 4, 8, 16, and 32 seconds, do the following:

 a. Expose the entire paper for 1 second.

 b. Cover a portion of the paper (about 1/6), and expose again for 1 second.

 c. Cover an additional portion, and expose for 2 seconds.

 d. Cover a still greater portion, and expose for 4 seconds.

e. Cover a yet greater portion, and expose for 8 seconds.

f. Cover all but the remaining (1/6) portion of the paper, and expose for 16 seconds.

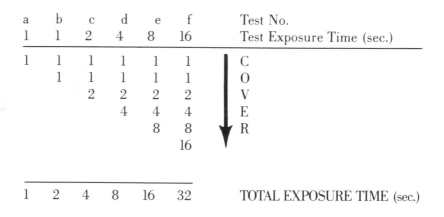

a	b	c	d	e	f	Test No.
1	1	2	4	8	16	Test Exposure Time (sec.)
1	1	1	1	1	1	C
	1	1	1	1	1	O
		2	2	2	2	V
			4	4	4	E
				8	8	R
					16	
1	2	4	8	16	32	TOTAL EXPOSURE TIME (sec.)

4. Process the exposed paper (described in detail in Procedure for Tray-Processing of Black and White Prints, pp. 119-120).

5. Inspect the finished print, and select the total exposure time that produced the greatest number of highest-quality images for a proof sheet, or the highest quality exposure for a single projection print.

6. Make the final print at the chosen exposure time.

7. Evaluate the final print by viewing it under a white light (not safelight). Check to make sure the print has a black area and a white area, with detail.

Photo finishers use a **photometer** to determine the exposure and contrast grade paper needed for a machine-correct print. The print so produced might not be the best or most creative one possible for the image. however, it will be correct in overall contrast and exposure.

Even though machine-correct exposure and contrast can be determined with a photometer, amateur photographers usually base their selection on a careful inspection of the proof sheet made when the film roll was first processed.

Special Print Exposing Techniques. Special print exposing techniques usually involve changing the exposure in a localized area of the print. Two of these techniques are dodging and burning-in.

Dodging is holding light back from areas that would otherwise print too dark (Fig. 10-8). Although expensive dodging tools are available at local camera shops, you can do the job just as well for a fraction of the cost by using your hand or a piece of cardboard held by a piece of wire. Whatever kind you select, the dodging tool is held between the lens and the printing paper so as to cover the area to be lightened. The tool should be close enough to the lens to be out of focus and should be kept in constant motion so that its image is not projected onto the paper in one area for too long a time. It is also important not to hit the lens during exposure.

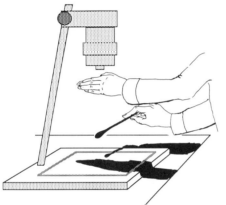

Figure 10-8a. Dodging entails passing an opaque object across the path of exposing light in order to decrease exposure to an area that would otherwise print too dark, as in the shadow areas of the accompanying prints.

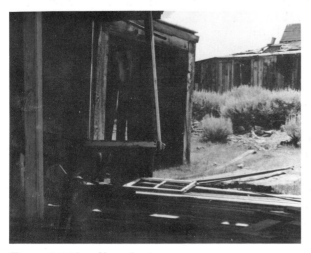

Figure 10-8b. Normal print

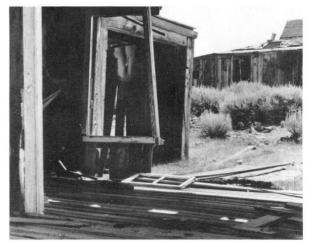

Figure 10-8c. Print after dodging

The opposite of dodging is **burning-in.** A print area that is too light may be darkened with extra exposure to that area (Fig. 10-9). The paper is given an initial exposure that is correct for all but the light area of the print. A second exposure is projected through a hole in a piece of opaque material onto the underexposed area only. As with dodging, it is important in burning-in to keep the tool close to the lens without striking the lens and to keep it in constant motion throughout exposure.

If variable contrast paper is being used to make the print, dodging or burning may be achieved using variable contrast filters to correct a localized contrast problem.

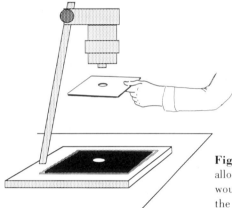

Figure 10-9a. Burning-in is achieved by allowing extra light to expose an area that would otherwise print too light, such as the window area.

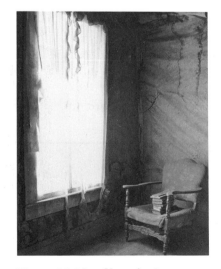

Figure 10-9b. Normal print

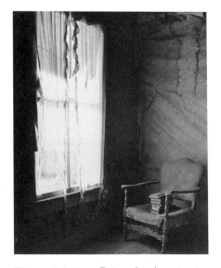

Figure 10-9c. Print after burning-in

Print Processing

The basic steps and rules for processing prints are the same as those for processing film (see Ch. 9). However, because prints are processed using trays rather than a tank and the chemical solutions serve for more than a single print, great care must be taken to avoid contamination among the various chemicals. It is a good practice to use one set of tongs for developing and another set for the stop bath and fixing.

Developing Solution and Developing Times. Most photographers use a developing solution that combines Metol with a higher percentage of Hydroquinone than found in normal negative developers. Although such a solution will produce a negative with high contrast when processing film, when processing prints, it yields a print of normal contrast. Because most print developers are stored at concentrated strength to increase shelf life, they must be diluted before use. Processing solution temperatures are best maintained at around 70°F, and all solutions should be at the same temperature to prevent reticulation.

Developing times will vary with the type of paper, with most papers developing fully in 1 to 3 minutes. Follow the manufacurer's recommended time as an overdeveloped print may result in a fogging of the light areas of the image and reduce the print's contrast range. Underdeveloped prints may exhibit spots or streaks.

Figure 10-10 Print processing.

Placing print into developer

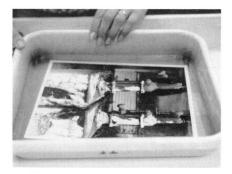

Agitation

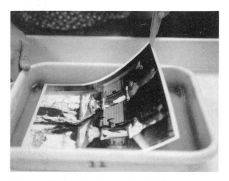

Removal of print from chemicals

PROCEDURE FOR TRAY-PROCESSING OF BLACK AND WHITE PRINTS
(See Fig. 10-10)

1. Once the darkroom is set up for printing, **fill** the **trays** with their respective chemicals in the following order: fixer first, then stop bath, and finally diluted developing solution. In this way, no fixer can splash into the developer tray and ruin the developer.

Developing

2. Immediately **immerse** the print completely **in the developer.**

3. **Agitate** the developer **tray** continuously. Agitation should be random so that no patterns form that might streak the print. This can be achieved by lifting first one side of the tray and then another throughout the developing cycle.

4. About 15 seconds before the end of developing, lift the print out of the tray by a corner with the developer tongs and let the developer **drain** back into its tray.

Stop Bath

5. Immediately **immerse** the print **in** the acidic **stop bath** and continuously **agitate** for approximately 30 seconds. This will stop the action of the developer and put the print in an acidic state that will more easily accept the acidic fixer.

6. At the end of the stop bath, lift the print out of the tray with the stop bath-fixer tongs, and allow the excess stop bath to **drain** back into its tray.

Fixing

7. **Immerse** the print **in** the **fixer.**

8. **Agitate** the print to prevent streaking. To avoid fading the print, do NOT overfix. For fiber-base papers, fixing is complete in about 10 minutes in sodium thiosulfate solution. RC paper is fixed in 2 to 4 minutes in sodium thiosulfate. With ammonium thiosulfate fixer, cut these fixing times in half.

Washing

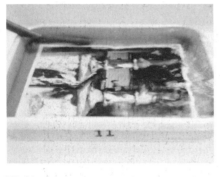

Washing

9. **Wash** the prints for permanency. Single-weight paper should be washed for 1 hour and double-weight paper for 2 hours. A washing agent such as hypo neutralizer can be applied to reduce the required washing time for single-weight paper to 10 minutes and for double-weight paper to 20 minutes. RC papers need only a 5-minute wash, *without* added neutralizer. The wash water should be flowing fast enough to give a complete water change every 5 minutes.

Drying

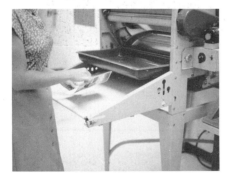

Drying

10. **Dry** the prints on a heat dryer or in a blotter book. RC prints can be dried by hanging them in room air or by blowing them with a hair dryer. Avoid excessive heat, which might curl the prints.

Print Finishing

A good print can be further improved after processing by retouching it and by mounting it properly. Unfortunately, many good prints are unnecessarily lowered in quality when the photographer does not carry through with correct print finishing.

Removing Spots. Perhaps the most important finishing step for photographic prints is the removal of spots. When there are white spots on the print from dust or opaque objects on the negative, a gray dye can be applied over the spots with a fine watercolor brush. Apply a light coating of the dye, and build up to the proper degree of darkness. A spot that is too dark is difficult to correct (Fig. 10-11a). Black spots can be removed from the print surface by gently etching (scraping) them with a sharp blade or applying a bleach solution. As with spotting, work slowly making sure not to remove too much silver or scratch the surface of the print (Fig. 10-11b).

Figure 10-11 Removing print spots.

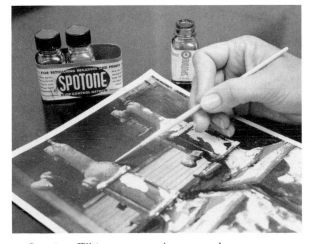

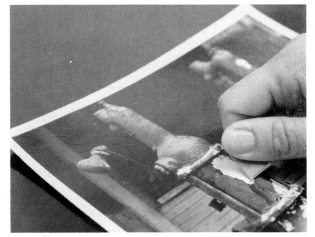

a. Spotting. White spots can be removed by brushing on a special dye.

b. Etching. Black spots can be removed by etching (scraping) them.

Toning. Special chemicals are available that can alter a black and white print's tones—either on the entire print or on selected areas (Fig. 10-12). In selective toning, rubber cement or "maskoid" is first applied to the areas you do not want toned. Most toners produce strong odors and some are toxic; therefore wear rubber gloves while applying them.

Mounting. Prints can be mounted on board in several different ways: rubber cement, dry mounting, and window mat. **Rubber cement** is an excellent method, one of whose advantages (if

properly applied) is that the print can be removed from its mount without damage.

Dry mounting uses a tissue that turns to glue when heated, thereby securing the print to the mounting material. The heat can be applied with either a dry-mount press or a household iron (Fig. 10-13). However, RC prints must not be mounted at too high of a temperature, or damage to the print surface may result. Because dry mounting is permanent, it must be done with care. With a **window mat,** the print is affixed to its mount board with hinged tape. This method is popular for archival mounting, because the print can be easily removed from its mat and stored in a dark environment.

Figure 10-12 Toned prints. (Courtesy of Donald B. Rex)

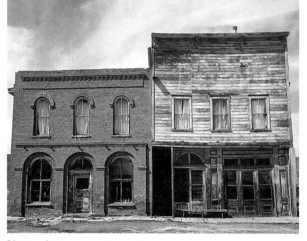

Untoned

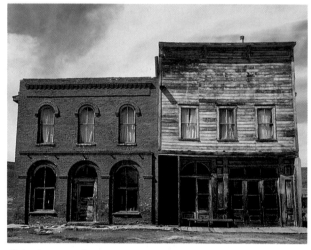

Selenium toned

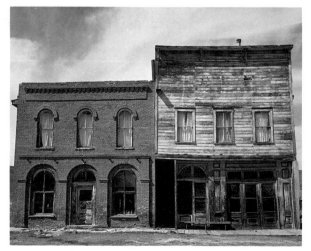

Brown toned

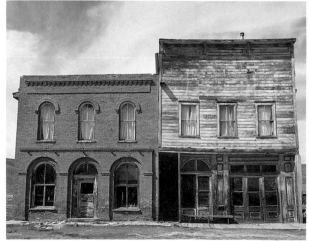

Sepia toned

Precautions for Archival Prints

Valuable prints can be ruined over a long period of time if adequate precautions are not taken. Galleries, archives, and collectors know that various factors contribute to premature deterioration of a print.

1. Fiber base paper is the only acceptable archival paper. Off-gassing of chemicals inherent in RC paper can fade or stain a print.
2. Only fresh processing chemicals must be used to avoid a stain that would become apparent after a long period of time.
3. Use of a two-step fixing bath helps assure that all silver halides are removed from the print, thereby preventing further darkening of the print.
4. Use a residual fixer test to make sure washing is complete.
5. Dry at lower temperatures.
6. Mount on acid-free board using paper hinges. Other mountings will, over time, introduce acid or sulphur which will affect the print.
7. Protect framed prints with ultraviolet-absorption-coated glass or plastic.
8. Prints should be protected from high temperatures and high humidity should also be avoided.
9. Exhibition under tungsten illumination, rather than fluorescent lighting will help prevent fading caused by ultraviolet radiation.

Checklist for Successful Printing

☐ Make sure your negative is clean. A little spot on the negative becomes a big spot on a print.

☐ Be sure to check the manufacturer's directions.

☐ Use only the safelight that is correct for the paper you have chosen. Different papers require different safelights.

☐ As in developing negatives, your thermometer must be accurate. ALL temperatures must be similar to prevent reticulation.

☐ Use only fresh chemicals.

☐ Be careful not to scratch your print with the tongs.

☐ Your developing time may vary depending upon your choice of paper.

Figure 10-13 Dry mounting. First, the print is tacked lightly to the mount (at the corners of the print) with dry-mount tissue. A tacking iron is being used here, but a household iron (set on low, wash and wear) would also work. The heat and uniform pressure of a dry-mount press then secures the mount.

Tacking

Mounting

☐ Correct agitation in the developer will assure even development, and correct agitation in the remaining steps will prevent stains.

☐ Don't allow fixer to contaminate your developer. This will ruin your print!

☐ Do not overfix because the image may be bleached and spotting becomes more difficult.

☐ Make sure that your wash time is correct for your paper type.

Common Printing Errors

Normal Print

High-Contrast Print—Lack of middle tones, rapid shift between black and white tones.
Probable Cause—This print was exposed on a paper with a contrast range that was too high for the negative.
Correction—Print on a paper with a lower contrast range that is suited for this negative.

Low-Contrast Print—No black or white tones in the print, only grays.
Probable Cause—This print was exposed on a paper with a contrast range too low for the negative.
Correction—Print on a paper with a higher contrast range that is suited for this negative.

High-Contrast Print

Low-Contrast Print

Underexposed Print—Overall light print with normal contrast. No blacks and lack of detail in the highlights.
Probable Cause—Not enough exposure.
Correction—Increase exposure.

Overexposed Print—Overall dark print with normal contrast. No whites and dark highlights.
Probable Cause—Too much exposure.
Correction—Decrease exposure.

Underexposed Print

Overexposed Print

Underdeveloped Print—Mottled gray print.
Probable Cause—Print was overexposed and removed from the developer before the proper time in an attempt to save the print.
Correction—Shorter exposure followed by proper development.

Laterally Reversed Print—Print is a lateral reversal (note printing on fire alarm).
Probable Cause—Negative placed in the projection printer with the emulsion facing up.
Correction—Turn negative over in negative carrier so the emulsion side of the negative faces the emulsion side of the printing paper.

Underdeveloped Print

Laterally Reversed Print

Black Fingerprints—Black fingerprints in image area.
Possible Cause—paper touched with fingers wet with developer before development.
Correction—Be careful not to contaminate print paper with chemistry.
White Fingerprints—White fingerprints in image area.
Possible Cause—paper touched with fingers wet with fixer before development
Correction—Be careful not to contaminate print paper with chemistry.

Black Fingerprints

White Fingerprints

Uneven Development—Uneven tones.
Probable Cause—Print not completely submerged in developer.
Correction—Be sure to completely submerge the print in all processing solutions.

Blistered Print—Print covered with blisters. Emulsion may be torn.
Probable Cause—RC print dry mounted at too high a temperature.
Correction—Make sure that dry mount press is not above 180°F when mounting RC prints.

Uneven Development

Blistered Print

Chapter 11

History of Photography

Although the history of permanent-image photography can be traced back to 1822, the origins of all of photography are really rooted as far back as the fourth century B.C., when Aristotle wrote of seeing multiple images of a solar eclipse projected onto the ground through the transient openings between the leaves of a tree (sort of a natural camera). (Aristotle also studied the photochemical action of light, noting that all plants remain white while in the ground and turn green only when they emerge into the world of sunlight and heat.) Aristotle's principles of projected images became the basis for the much later discovery of the camera obscura.

Camera Obscura

It is unknown who discovered the camera obscura, or exactly when the discovery took place, but the first published account of its use is dated 1267. The camera obscura (literally *darkened room*) was described in detail in 1490 by Leonardo da Vinci (Fig. 11-1). He wrote that an image of an outdoor, sunlit subject could be projected through a small aperture cut in a piece of sheet iron onto a sheet of thin paper located across a room.

Artists of the time discovered an application for the camera obscura. They would trace the projected image and thereby form an outline for a painting that could be finished later. Even though some artists believed this was "cheating", the camera obscura continued to be used this way for many years.

One of the numerous improvements on the early camera obscura came in 1568 with the addition of lenses for focusing light instead

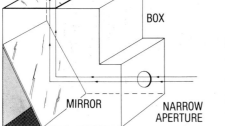

Figure 11-1 Camera obscura. As the camera obscura evolved, its use necessitated miniaturization into a box-shaped device that could be carried into the field by the artist. Light enters the camera obscura through the aperture in the front of the light-tight box and is then reflected from the interior mirror to the tracing surface located on the top of the camera.

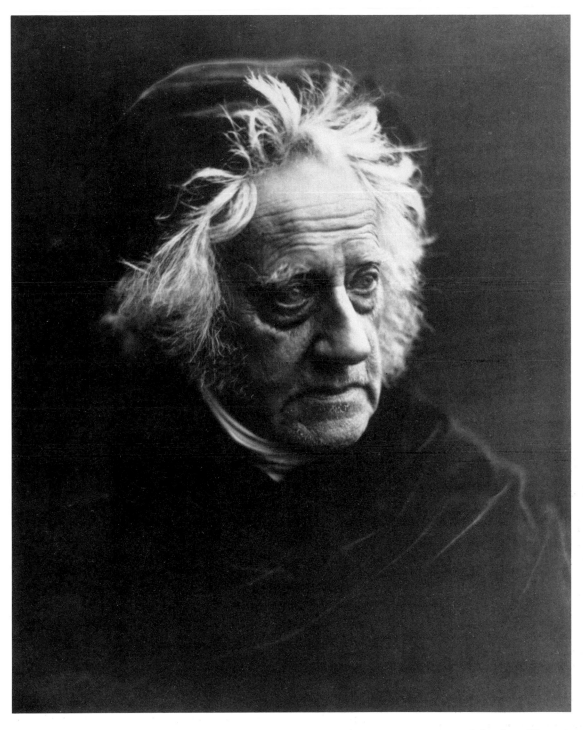

Figure 11-2 Sir John Herschel, son of Sir William Herschel (the astronomer who discovered the planet Uranus), proposed the use of fixer and coined the terms photography and snapshot. (Courtesy of International Museum of Photography at George Eastman House)

of merely collecting it, as the pinhole aperture did. Although the lens system brightened and sharpened the camera obscura image, without a photosensitive receiving medium, the artist still had to trace the image.

Early Photosensitive Materials

The earliest research into light-sensitive materials was conducted by Johann Heinrich Schulze in 1727. By mixing silver nitrate with powdered chalk, he proved that light alone could cause the silver compounds to darken. Schulze produced many liquid stencil images by wrapping various cuts of black paper around a bottle of the silver nitrate mixture. He never applied his solution to a receiver such as paper, so these liquid stencil images would disappear as soon as the bottle was agitated.

In 1777, the Swedish chemist Carl Wilhelm Scheele, working with silver chloride, confirmed Schulze's conclusion that it was light that caused the silver compounds to darken. By bathing the darkened substance with ammonia, Scheele also proved that the dark compounds were metallic silver. (Ammonia dissolves silver chloride but not metallic silver.) Even though all the elements for permanent-image photography now existed—the camera obscura, a light sensitive material, and a chemical for removing unexposed silver halides—Scheele's discovery was largely ignored.

In 1802, Thomas Wedgewood published a research paper in the *Journal of the Royal Institution* in which he described his work on sensitized paper. By soaking paper in silver nitrate, Wedgewood had produced photograms similar to Schulze's stencils. Being unfamiliar with Scheels's work, Wedgewood concluded "nothing but a method of preventing the unshaded parts of the delineation from being colored by exposure to the day is wanting to render the process as useful as it is elegant."

The action of fixing bath was discovered in 1819 by Sir John Herschel (Fig. 11-2). Herschel found that silver halides readily dissolved in a chemical called hyposulfate of soda, or sodium thiosulfate, which allowed unexposed halides to be removed from a photographic emulsion without endangering the silver metal that made up the image.

Niepce and Heliography

In 1816, Joseph Nicephore Niepce had used the camera obscura to expose materials sensitized with silver nitrate (Fig. 11-3). He managed to produce negatives after exposures of several hours, but, being unfamiliar with the work of Herschel, he was unable to remove the unexposed silver halides and fix the image. To stop the

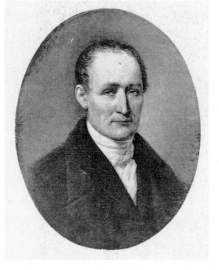

Figure 11-3 Joseph Niepce produced the first permanent photographic image in 1824 by a process he called heliography. (Courtesy of International Museum of Photography at George Eastman House)

unwanted darkening of the images, Niepce began to experiment with materials other than silver, specifically, asphaltum.

In trying to reproduce engravings, Niepce had found that asphaltum (bitumen of Judea) would harden when exposed to light and that unexposed (therefore softer) materials would dissolve in lavender oil, leaving a relief image of the exposed areas. Using this technique, Niepce had by 1822 successfully copied an engraving of Pope Pius VII. In 1824, he placed a thin plate of pewter coated with Asphaltum emulsion in a camera obscura for exposure out a window. By the end of about eight hours of exposure, the plate displayed the vague outlines of roofs and chimneys—the first permanent photographic image. He called the process **heliography,** or sun writing (Fig. 11-4).

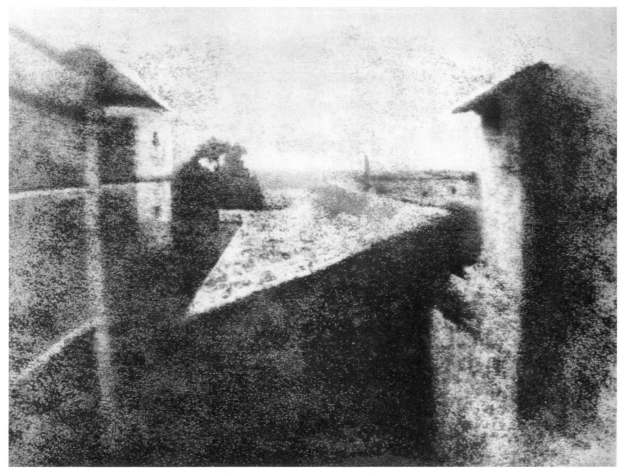

Figure 11-4 Niepce's first heliograph. From the length of the shadows located on each side of the buildings, it is surmised that the exposure was approximately eight hours. The photograph shows the Niepce courtyard in Gras, France, as viewed from the window of Niepce's workshop. The building on the left was called the pigeon-house by the family. A pear tree is between the pigeon-house and the long building (the bakehouse). The structure on the right is another wing of the family home. (Courtesy of Gernsheim Collection, Humanities Research Center, The University of Texas at Austin)

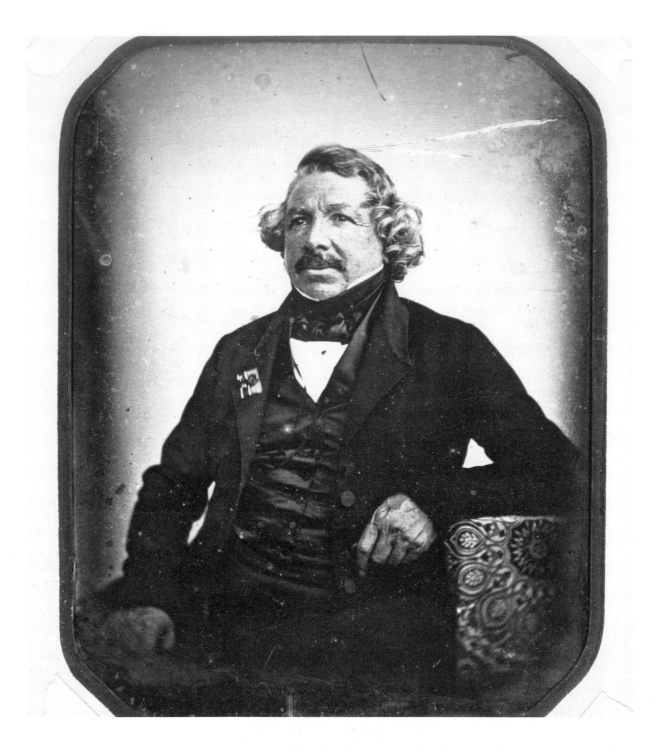

Figure 11-5 Louis Daguerre, in partnership with Niepce, invented the daguerreotype. (Courtesy of International Museum of Photography at George Eastman House)

Niepce Meets Daguerre. In the meantime, French painter Louis Jacques Mande' Daguerre (Fig. 11-5) had also been working with the camera obscura and had attempted exposures using silver as the photosensitive material and common table salt as the fixing agent. Encouraged by mutual friends who knew of their work, the two experts formed a partnership in 1829 to mutually improve the heliographic process. After only a few meetings, the partners never saw each other again, although their work on silver iodide as a possible photosensitive material continued for four years, with the results relayed by mail. In 1833, Niepce died of a stroke, still convinced that asphaltum was the best photosensitive material.

Daguerreotype

Following Niepce's demise, Daguerre discarded all the work with asphaltum, took Niepce's son Isidore as his partner, and continued research into the photosensitive properties of silver iodide. In 1835, Daguerre discovered that mercury vapor could produce a visible image on a silver plate treated with iodine. He fixed the image with common table salt. Although Isidore Niepce had nothing to do with this discovery, Daguerre included him in plans to form a company to exploit it. In 1839, Daguerre applied for a patent from the French government for the process, which he called **daguerreotype.** The application was denied on the grounds that the process should be public property, being too significant to belong to just one person. As consolation, the government offered each of the two inventors a lifetime pension. Unknown to the French government,

Figure 11-6 The daguerreotype. (Courtesy of International Museum of Photography at George Eastman House)

a. Montgomery Street, San Francisco, late 1880's. The blur of motion in the foreground was caused by the extremely long exposure required by the daguerreotype process. Because the daguerreotype is an image reflected from a mirror, the print is a lateral reversal of the original scene (which is why the street numbers and signs read backwards).

however, Daguerre had secretly patented the process in England a few days before his August 19, 1839, formal announcement in France.

Characteristics. In the daguerreotype process, a copper plate coated with high-quality silver polished to a mirror finish was sensitized in a wooden cabinet with fumes of iodine that combined with the silver to form silver iodide. The sensitized metal plate was then exposed via a camera obscura for 6 to 10 minutes in bright sunshine. The latent image was developed in a cabinet over a tray of heated mercury, whose vapors would attach to the exposed silver iodide to produce an amalgam of silver and mercury. Although at first Daguerre fixed the developed image in a concentrated solution of table salt, after learning of Herschel's work, he used sodium thiosulfate as the fixing agent. The washed and dried daguerreotype was then sealed in a glass frame for protection (Fig. 11-6). The resulting photograph was quite elegant, although difficult to view.

The sharpness and tonal range of the daguerreotype image rivals the best photos of today. Shades of gray were created with varying thicknesses of the silver-mercury amalgam; black areas were created with the unexposed, undeveloped silver of the polished mirror; and pure whites were reflections from the completed mercury surface.

Problems. There were several serious problems with the daguerreotype, two of them stemming from the fact that one had to view the image as reflected from a mirror. For one thing, to be

viewed, the daguerreotype image had to be held in the hand rather than hung on a wall, for if not viewed straight on, the image appeared to be a negative rather than a positive. Second, the daguerreotype image was a lateral reversal of the actual scene, something that could not be corrected. Perhaps the worst deficiency of the daguerreotype was that there was no way to make copies of the original; one could only make more originals of the same scene.

Many improvements followed, with more sensitive emulsions and faster lenses leading the way to shorter exposures. But the daguerreotype was obsolete even before it was formally introduced because of the invention of the negative-positive photographic process by William Henry Fox Talbot (Fig. 11-7).

Fox Talbot's Calotype

William Henry Fox Talbot began his photographic research in 1834 using paper sensitized in silver nitrate and table salt. He produced photocopies and photograms with this process and fixed them in table salt. Later he discovered he could print through the paper base and create a positive image on a fresh piece of sensitized paper. He described the process in a paper to the Royal Society in January 1839 (roughly seven months before Daguerre made his process public) and patented his **calotype** in 1840 (Fig. 11-8).

The calotype process made use of paper sensitized with silver iodide and developed in pyrogallic acid. Exposure took approximately one minute in full sun. Although the calotype solved the reproduction problem of the daguerreotype, its positive image was never truly sharp, because it was made by passing light through a paper negative. It was left to another Britisher to devise a better negative support than paper.

Wet-Collodion Process

In 1851, Fredrick Scott Archer (Fig. 11-9) solved the problem of the fuzziness in Fox Talbot's calotypes by employing collodion to bind the photographic emulsion to a glass plate. (Collodion, invented in 1846 by French chemist Louis Menard, was being used to dress minor wounds by applying it wet over an abrasion and letting it dry to form a protective coating.) Scott Archer would apply to a glass plate an even coat of collodion (cellulose nitrate in alcohol-ether) mixed with potassium bromide and potassium iodide (or ammonium bromide and ammonium iodide). Once the coating had set, the plate was soaked in silver nitrate, thereby forming silver iodide in the collodion layer.

In the **wet-collodion process,** the camera exposure had to be made before the plate dried, otherwise all photosensitivity was lost.

Figure 11-7 William Henry Fox Talbot, inventor of the calotype. (Courtesy of International Museum of Photography at George Eastman House)

Figure 11-8 The calotype. (Courtesy of International Museum of Photography at George Eastman House)

a. World's first negative, photographed in August 1835, shows Fox Talbot's workroom window. The note is in Fox Talbot's handwriting and tells how many individual window panes are discernible in the image.

b. This early Fox Talbot light drawing is a photogram on "salted paper" of a piece of fabric from the Talbot family home, Laycock Abbey, England.

Exposures as brief as five seconds were possible because of the increased sensitivity of the plate. After exposure, the plate was developed in pyrogallic acid and silver nitrate, fixed in sodium thiosulfate, washed, and dried. The finished plate was a transparent negative from which any number of high-quality photographic reproductions could be made (Fig. 11-10). The development of this photographic system soon led to the demise of the daguerreotype process.

Figure 11-9 Frederick Scott Archer, inventor of the wet-collodion process. (Courtesy of International Museum of Photography at George Eastman House)

Figure 11-10 This wet-collodion plate was taken by T. O'Sullivan during his travels through the western United States. Notice the horses that were used to carry equipment (upper left) and the extra camera (upper right). (Courtesy of International Museum of Photography at George Eastman House)

Offshoots. The **ambrotype,** using an underexposed, wet-collodion plate with a black backing, produced a positive-appearing image (Fig. 11-11). The plate with its backing was usually displayed in a plush case similar to a daguerreotype display case; in fact, the ambrotype was frequently mistaken for a daguerreotype.

The **tintype,** which employed a collodion emulsion coated onto japanned (varnished) metal plates, was patented in 1856 by Hannibal Smith, an American, and became very popular because of its low price and the speed with which it could be processed. The tintype image was also quite durable; many tintypes were mailed to loved ones far away (Fig. 11-12).

The **carte-de-visite,** made from a wet-collodion glass-plate negative, was distinguished by its camera and print size. The camera had multiple lenses so that many separate images of the same subject could be exposed at one time. The plate of images was then contact-printed onto paper and each print cut and mounted onto cardboard the size of a calling card. Cartes-de-visite of many dignitaries of the time were sold to the general public.

Dry-Plate Process

The inconvenience of the wet-collodion plate stimulated the search for a dry-plate process, one that would allow the photographer to purchase premanufactured plates capable of being stored for later exposure and processing.

In 1871, Dr. R. L. Maddox described a gelatin-based material that was conveniently dry but was less sensitive than wet collodion. A much more sensitive emulsion was invented in 1878. These plates used purified gelatin, excess soluble bromide, heat, and ammonia. After these premanufactured plates were made available to amateur photographers in 1878, many dry-plate factories opened in England, Belgium, Germany, and the United States.

Eastman's Innovations

In 1884, in Rochester, New York, the Eastman Dry Plate and Film Company was founded by George Eastman (Fig. 11-14 and 11-15a). Eastman was to popularize photography with numerous innovations in both equipment and processes.

In 1888, Eastman placed on the market a 100-exposure roll film on a base of nitrocellulose in methanol dissolved with camphor and amyl acetate, a film designed for a new camera to be marketed under the name of Kodak (Fig. 11-13). The camera, which sold for $25, came from the factory already loaded with the new type of

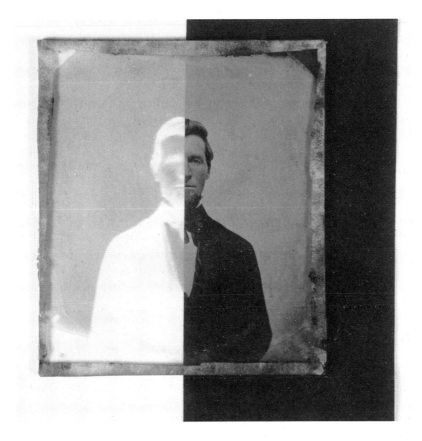

Figure 11-11 The ambrotype.
(Courtesy of International Museum of
Photography at George Eastman House)

a. The left half, without black backing,
appears as a negative; the right half, with
the backing, gives the appearance of
a positive image.

b. Full-plate ambrotype.

Figure 11-12 American Civil War tintype.
(Courtesy of International Museum of Photography at George Eastman House)

Exterior Interior

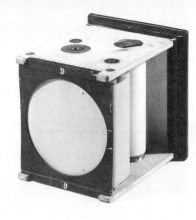

Figure 11-13 Kodak #1 camera. Notice the circular opening of the focal plane.
(Courtesy of International Museum of Photography at George Eastman House)

film. When all 100 frames had been exposed, the film—still in the camera—was returned to Eastman Company to be unloaded, processed, and printed (Fig. 11-15). The 100 circular prints would be returned to the user with a freshly loaded camera. The charge for all this was $10. The new camera and film, promoted with the slogan "You press the button, we do the rest," was quickly welcomed by photographers the world over.

The drawback of film that had to be loaded and unloaded at the factory, (because with no light protection it had to be handled in a darkroom) was solved in 1891 when the Eastman Company introduced paper-backed roll film, which could be loaded and unloaded in dim light. From then on, only the film had to be returned for processing. By 1905, a daylight-loading developing tank was on the market, enabling users to process their own film.

Twentieth-Century Developments

The twentieth century has seen the development of many new photographic systems and processes, continuing the movement started by George Eastman to make photography accessible to the general public.

Research into color photographic processes led to the introduction of Kodachrome film in 1935 and to the later introduction of color negative-positive film by many manufacturers. The 1982 Photokina exposition brought to the public color films of the highest ISO sensitivities ever using "T" grain technology that allowed for finer grain, as well as simplified processing techniques. A high speed Kodachrome film was introduced in late 1986.

Black and white research since 1900 has produced panchromatic films and many specialized printing papers. Higher ISO film speeds have also been achieved for black and white photography. "T" grain films, first introduced in color, were introduced in black and white films in late 1986. These films produce finer grain with higher speeds.

Camera innovations in the twentieth century have included auto focus cameras, auto exposure cameras using DX codes to set the ISO, instant-print cameras, 3-D cameras, and cameras of generally higher quality that are also easier to use.

In the future, research will undoubtedly produce materials and equipment that will open new directions for photographers while making it even easier to achieve high-quality results. Electronics will continue to play an ever-increasing roll in the design and application of cameras and processing equipment, and the search for a replacement for expensive silver as the recording medium will certainly continue.

Figure 11-14 George Eastman, founder of the Eastman Dry Plate and Film Co., later to be known as the Eastman Kodak Co. (Courtesy of International Museum of Photography at George Eastman House)

Figure 11-15 Photographs taken with the Kodak #1 camera. (Courtesy of International Museum of Photography at George Eastman House)

a. George Eastman on board ship during a trip to Europe to promote his Kodak #1 camera.

Figure 11-15 b.
The unsharpness at the edges of this photo is caused by spherical aberration. This aberration would be unacceptable in all photographs if the image were printed full frame instead of being cropped in the camera.

INDEX

Rotary slide rule for determining daylight exposure.

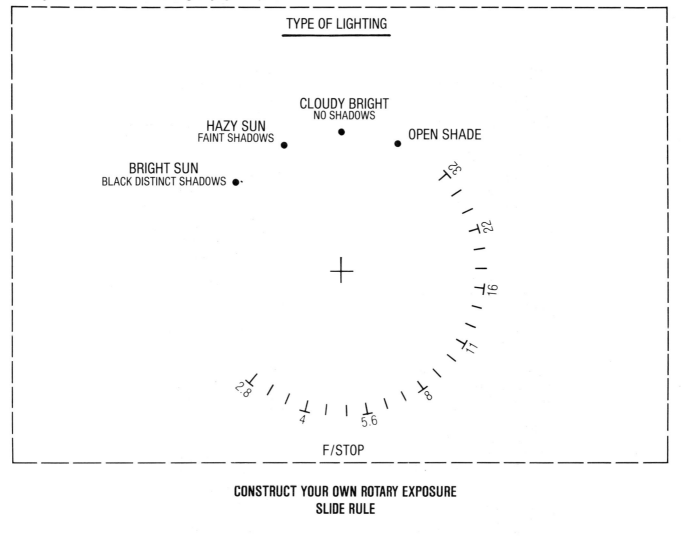

TYPE OF LIGHTING

CLOUDY BRIGHT
NO SHADOWS

HAZY SUN
FAINT SHADOWS

OPEN SHADE

BRIGHT SUN
BLACK DISTINCT SHADOWS

32
22
16
11
8
5.6
4
2.8

F/STOP

**CONSTRUCT YOUR OWN ROTARY EXPOSURE
SLIDE RULE**

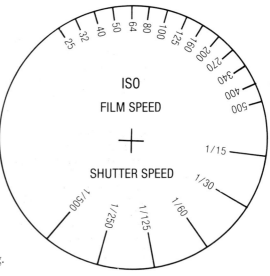

25 32 40 50 64 80 100 125 160 200 270 340 400 500

ISO

FILM SPEED

SHUTTER SPEED

1/15
1/30
1/60
1/125
1/250
1/500

1. First cut out **both** dials and mount them onto cardboard.

2. Attach the round dial to the rectangular base with a pin.
 Bend the pin over on the back and cover with tape.

3. Align the ISO speed of your film with the type of subject lighting.
 The equivalent F/stop and shutter speeds will be indicated.

About the Author

Michael Leary received his BS from Rochester Institute of Technology in Photographic Science and MA in Instructional Technology from San Jose State University.

He taught in the Photography Department of San Jose State from 1967 to 1970. Since 1970 he has been Department Chairman of the Photography/Journalism Department at West Valley College in Saratoga, California, in California's famous "Silicon Valley".

He is a Senior Member of The Society of Photographic Scientists and Engineers, and served as their national Educational Vice President for eight years. He has also been an officer of the local chapter of the society for many years.

A popular lecturer on Photography to professional groups, Mr. Leary's extensive world travel has added a global perspective to his photographic studies.